The Joe Beeler Sketch Book

JOE BEELER is one of the most versatile and able contemporary western artists. He is adroit with a pencil, and equally comfortable painting and sculpting. He is a founding member and past president of the Cowboy Artists of America. Numerous publishers have used his illustrations in their books over the past fifteen years, and his work in all media has been exhibited in one-man shows at major art institutions throughout the West.

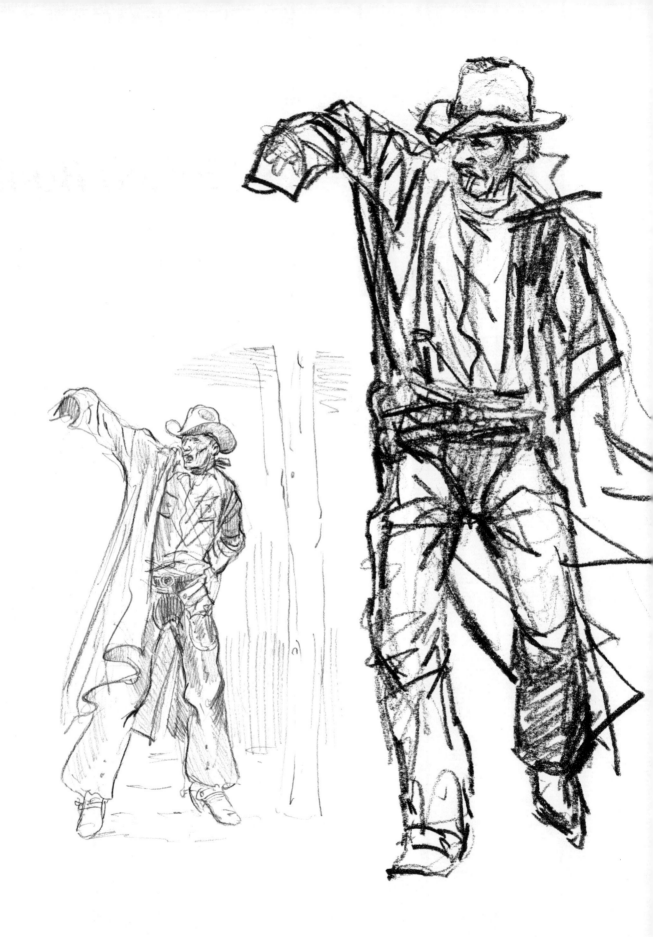

The Joe Beeler Sketch Book

by Joe Beeler

With a foreword by Frederic G. Renner

NORTHLAND PRESS

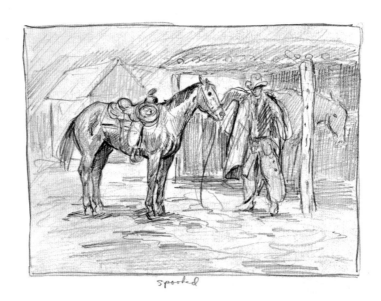

spooked

to Joe De Yong

Contents

Foreword

TO ME, AN ARTIST'S SKETCH BOOK tells more about the artist than seeing dozens of his finished paintings on display in some dealer's showroom. It doesn't matter if some of the sketches are doodles, as many of these are, or are serious preliminary sketches for finished paintings. There are more than two hundred such drawings in this book. There are Indians from a dozen tribes; Cherokee, Creek, Pawnee, Cheyenne, Kiowa and others the artist had known in Oklahoma, Apache, Papago and Navajo from Arizona, many of them his personal friends. There are also cowboys, old and modern; many sketches of "characters" with a unique appeal all their own; rodeo contestants; pugilists and football players from school days; a few soldiers from the artist's service in Korea; and always . . . horses. Examining and savoring these drawings, one by one, leaves me with the pleasant feeling that I have had the rare privilege of being invited into the artist's home and after several evenings of reminiscing about mutual friends and interests have gotten to know the artist himself.

 This sketch book tells me many things. Joe Beeler can draw, a talent I greatly admire and one I sometimes find lacking in those who would aspire to be artists. It is also obvious that Joe loves to draw, and does a lot of it. His sketches have such a spontaneity and naturalness about them that one can almost smell the dust and old leather, yes, and horse sweat. The hidden humor in many of the sketches in this book also reveal that the artist loves life, especially people, that he is thoroughly enjoying himself, and that his art is fun, which is as it should be.

ix

The text is equally delightful. In these rambling and unpretentious notes the artist recounts some of his personal experiences and explains many of the techniques of his craft. He tells us about the source of his subjects and why they appeal to him, the importance of a file of research material, how such sketches as are shown in the book are used in planning a finished painting, and especially the importance and accuracy of detail. He explains the care and understanding that have to be given not only to the costume and hairstyle of Indians of different tribes but to their different physical characteristics if one is to do acceptable historical paintings. As he put it ". . . being able to paint a naked figure on a running horse with stringy black hair flying and wearing a beaded belt and moccasins is not enough to call yourself a western artist."

Charlie Russell would have liked this book, as he would have enjoyed knowing Joe Beeler.

<div align="right">Frederic G. Renner</div>

Introduction

SKETCHING AND DRAWING are the basic tools of my trade. When I
was younger, I found that very few tools would fit my hands . . . so my
Father told me. A shovel and pick never did. Items like wrenches,
screwdrivers, mechanical drills and saws all were foreign to me. In fact,
I believe that most mechanical devices have it in for me personally.
Very early I found that things like pencils, brushes, ink pens and other
such useless items did fit me . . . things that no one could ever make
a living using. All my idle hours were spent with a pencil in my hand,
and in those days I usually drew on a Big Chief writing tablet, all
sprawled out on our dining room table.

Now at the same time there *were* a few other things that did seem to
fit my hands pretty well, for instance, a fishing pole, a double-barrel
shotgun or squirrel rifle, leather reins, and a baseball glove . . . but never
the long, round handles of such evil devices as shovels, rakes, hoes,
pitchforks and the like.

In my mind it wasn't a very manly trait. None of the other boys I
knew could draw, and only girls went in for that kind of stuff, and I
only did it for my own amusement and pastime. Artists were always
considered to be a little weird anyway, running around with funny
hairdos and clothes, so I sure didn't want anyone to put me in that
category (putting it in the terms of a close artist friend, Frank Polk,
who was discussing this one time, "My mother always told me that
artists always turned out to be queer or alcoholics . . . and I'm sure glad
that I'm an alcoholic"). I never took my drawing too seriously, and

1

there was no reason for anyone else to. I grew up just like the rest of the boys in our area, and I wasn't going to let drawing handicap me in any way.

I recall when I first made an impression on my friends and my debut as an appreciated talent. We were old enough to start goin' to dances, and there was one place in particular that everyone went to. They charged a pretty stiff admission when they had a live band on weekends or special engagements. At the entrance you paid, and they stamped your hand with some design so you could come and go, and they would know you had paid. A big, mean, stout fellow stood by the gate checking everyone. Someone got the idea that why should everyone pay to get in when I could free-hand draw the design on everyone's hand . . . for *nothin'*, and we could fool big Jim on the gate. We all gathered at a nearby hangout, and all chipped in to pay for one fellow's entry fee. He did this and returned to show what they had used on the back of his hand. I was prepared and had a pocket all full of assorted colored pencils. I picked the one that matched and went to work. We all got in without a hitch, although big Jim did start to give the last ones the evil eye . . . but I was the hero; my artistic ability had finally been discovered and appreciated by my discriminating friends.

The only importance the assortment of material in this book might have, if any, is that it serves to show how one artist thinks and how he develops. Most of these sketches were hurried, some are very simple and some are just doodles. Few were intended to be finished products, the exception being the pastel portraits and the book illustrations. At any rate, I have enjoyed my part in this book, and I hope that you as the reader will enjoy yours.

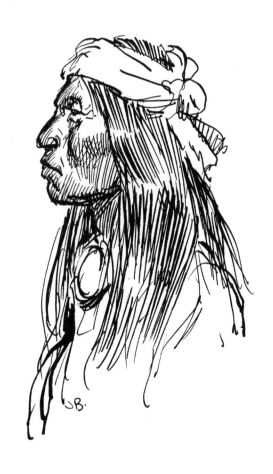

Early Works

MANY OF THESE SKETCHES date back to boyhood. It never seemed to matter or make much difference what I drew . . . I was always drawing something. It all came out of my head. I enjoyed coming home from some movie and drawing all the characters I had seen. I would even make up my own stories and illustrate them, like a comic strip. When World War II came along, I was about ten years old and preoccupied with drawing about the war and the soldiers. I would research the equipment they used so that everything would look right, their rifles and uniforms and the tanks and airplanes . . . all of it had to be accurate. My grandmother lived with us, and as a young girl she had traveled in a covered wagon to Oregon. Her many experiences on the frontier always fired my imagination . . . I couldn't make the trip myself so I drew about it.

4

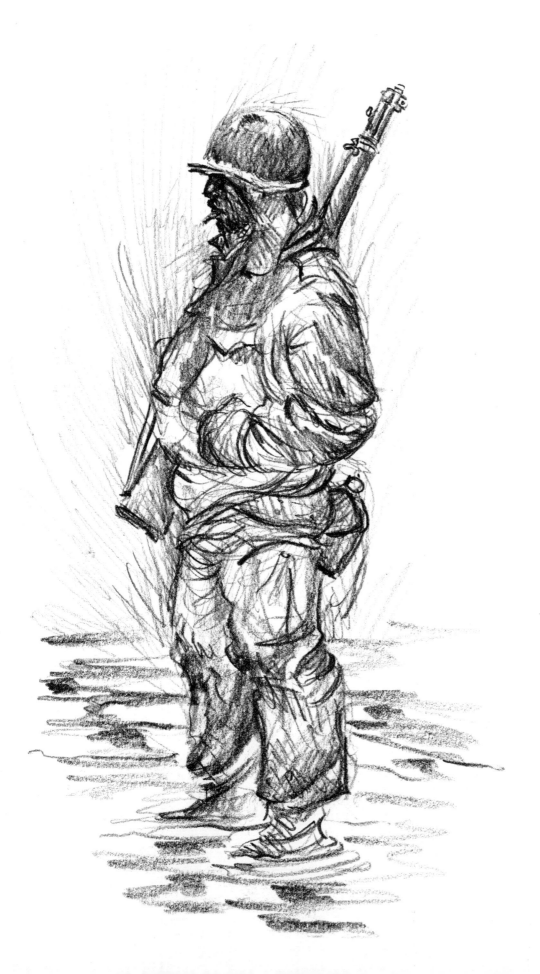

5

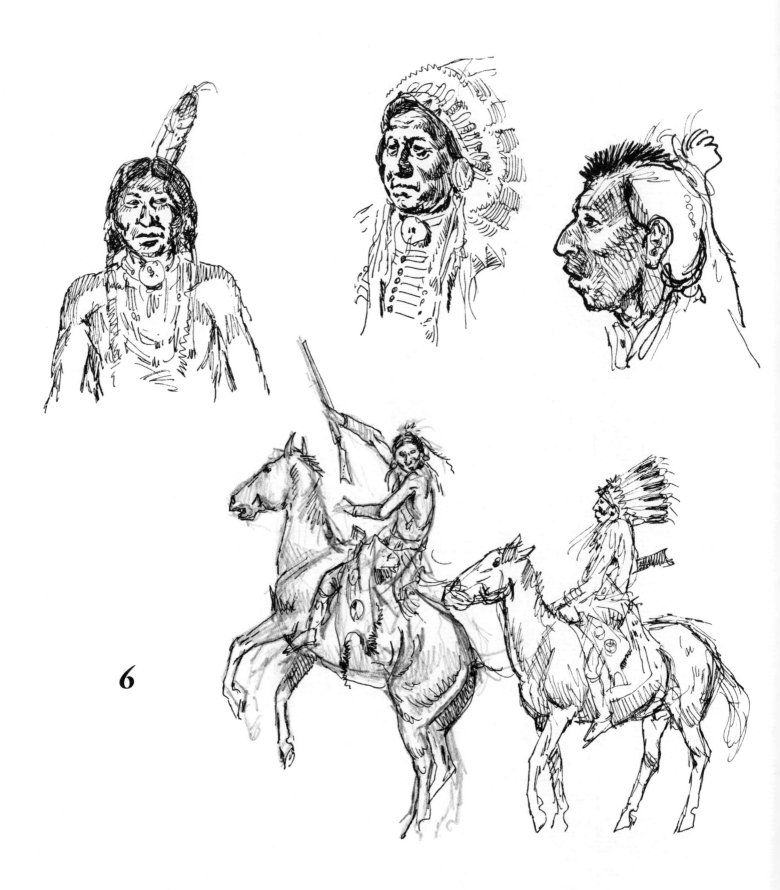

6

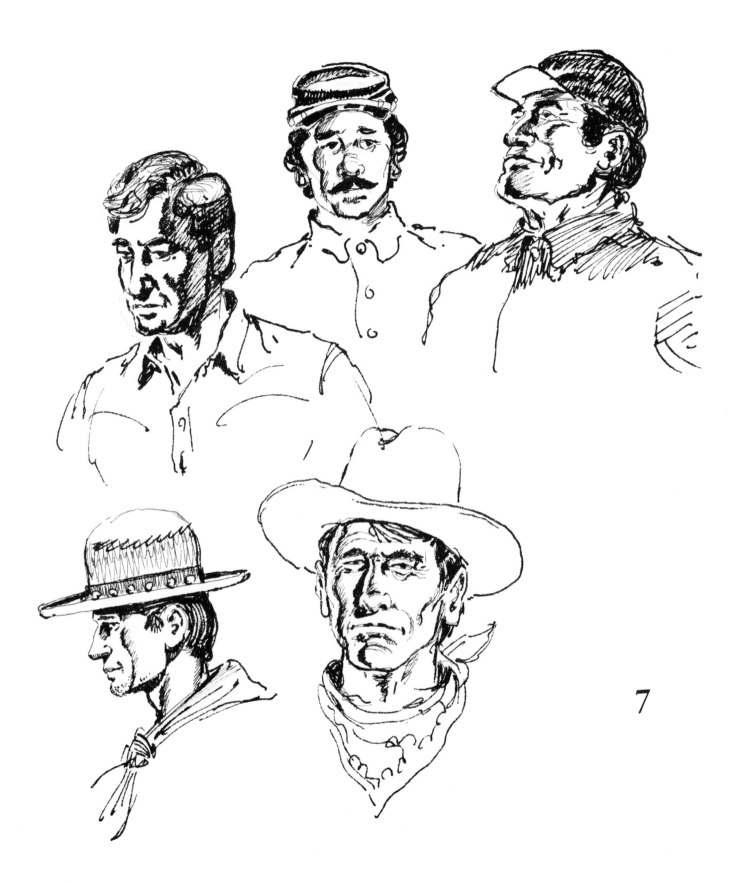

7

One summer our family took a trip to visit relatives in New Orleans. I was very much impressed with the Old South and the people. The side streets were lined with famous jazz joints, and even though I was too young to go in, I drew my impressions of them from just walking along and hearing the sounds drift out into the streets, imagining what it was like on the inside.

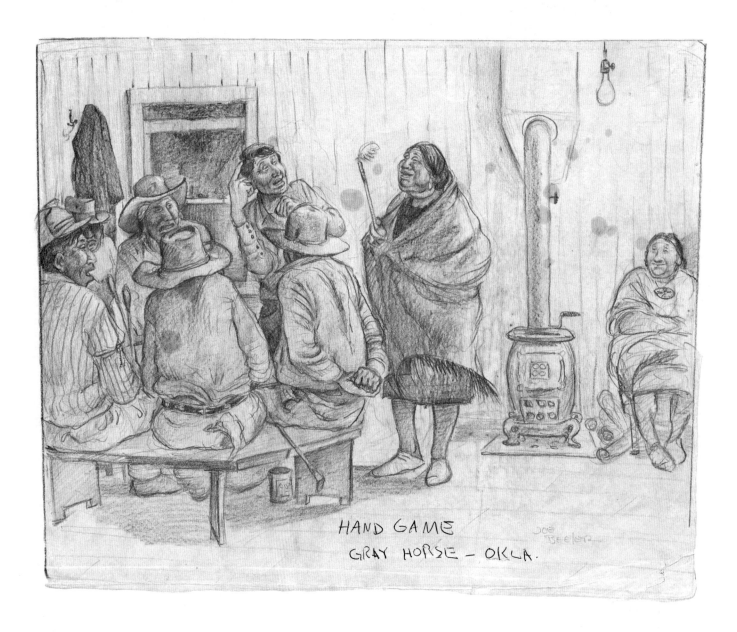

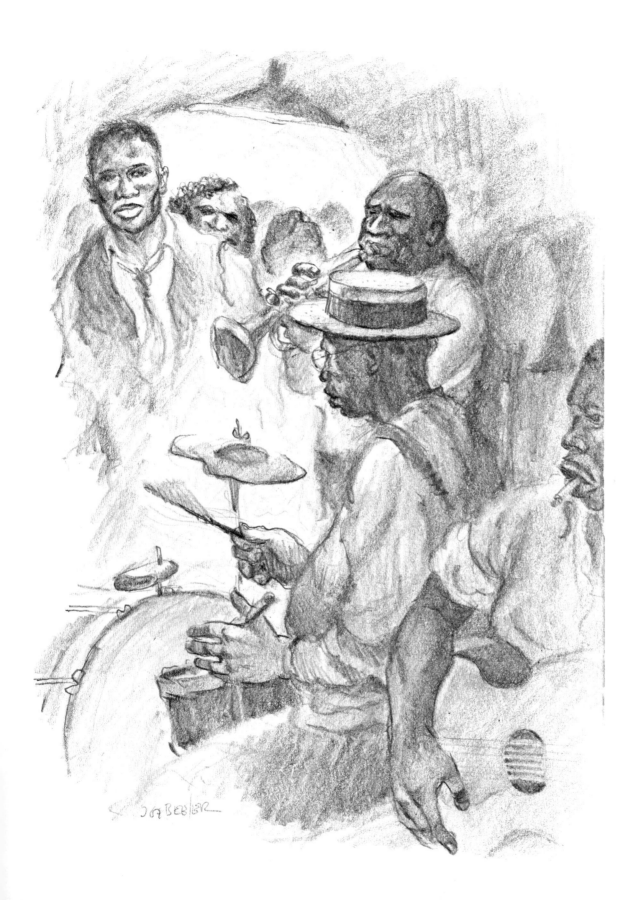

9

Sports gave me a chance to make action pictures. I didn't sit ringside and draw these fighters. They came from my memory after I got home from the fights. And my football players came from my days of playing football in high school and junior college. These were doodles done sometime later while thinking about what I had seen and how they moved. A rodeo, a golden gloves tournament, a football game or just my brother roping at a chicken with a piece of clothesline in our back yard . . . no matter what the sport or action, I enjoyed putting it down.

10

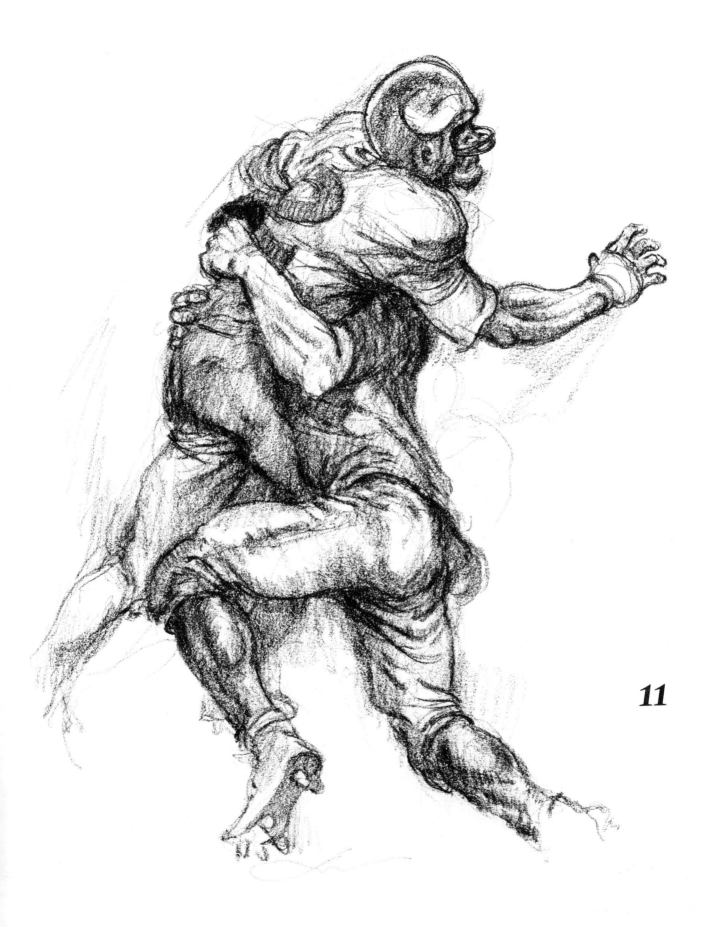

11

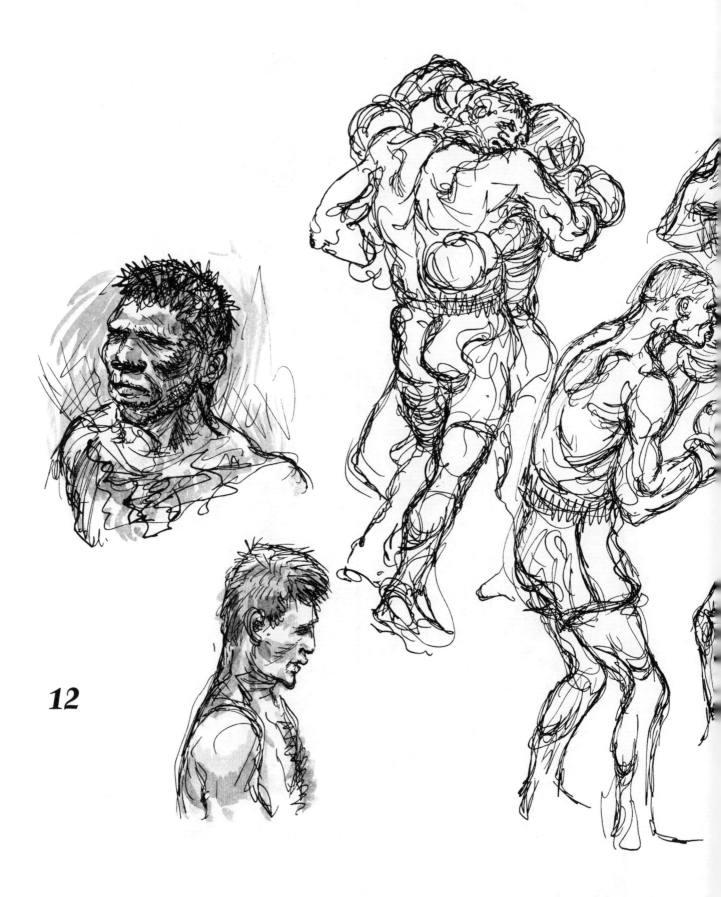

12

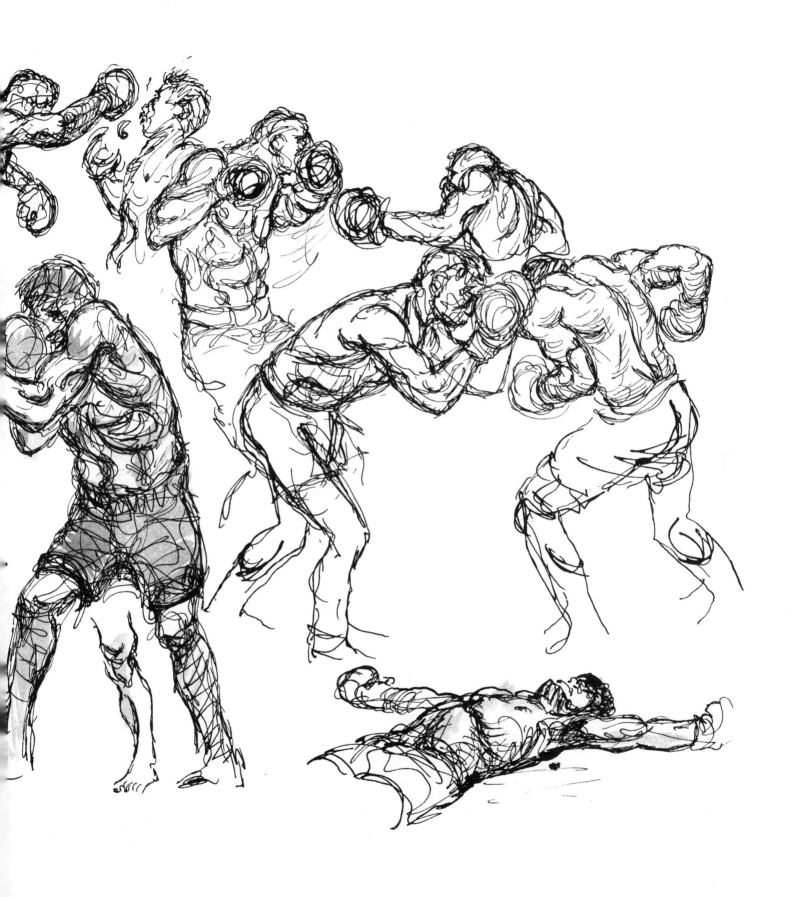

Several years ago I remember seeing Creek chief Joe Hicks playing stickball during the Pawnee Homecoming. I drew this later from memory, and I almost forgot the tennis shoes.

14

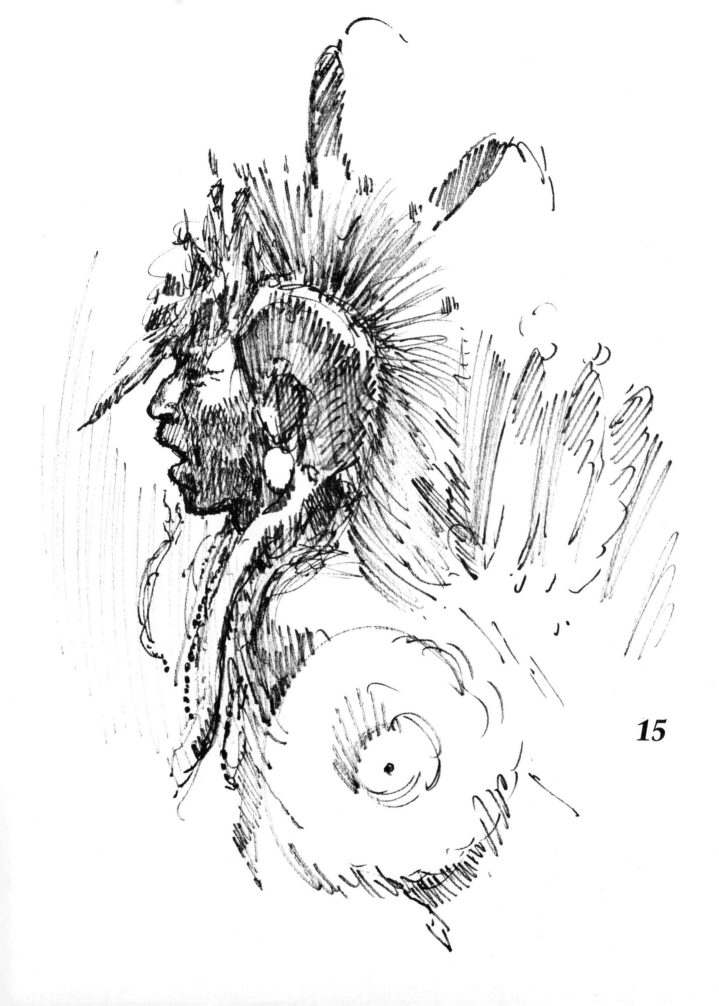

15

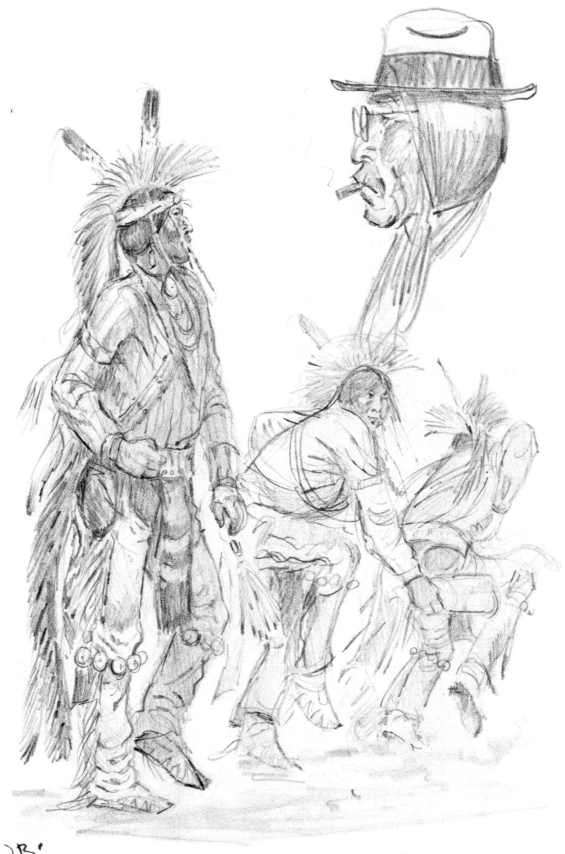

A tour of duty in the Army allowed me new subjects to draw. I carried a bound sketch book as a regular part of my gear all through the service. It kept me occupied during a lot of idle hours and probably off the streets and out of trouble at times. I had always liked to cartoon my friends and draw incidents that happened so it was natural to find the humor of military life.

I drew for several camp newspapers and the ship newspaper coming and going overseas. I drew for *Stars and Stripes* after arriving in the Far East. In Korea I was assigned to a medical unit and hospital at the end of the war. I had no medical background and didn't know why I had been assigned to such a unit. I thought a Bandaid was the fellow who carried the bass drum in the parades. Our company commander found this out, and so just to keep me out of trouble and maybe to keep me from killing one of the patients, I just drew pictures and pulled guard duty till my tour was over. I was reassigned an MOS number of a combat artist . . . but thank goodness, the war had come to an end . . . and the only combat involved finding room on a truck heading towards the debarkation depot and port.

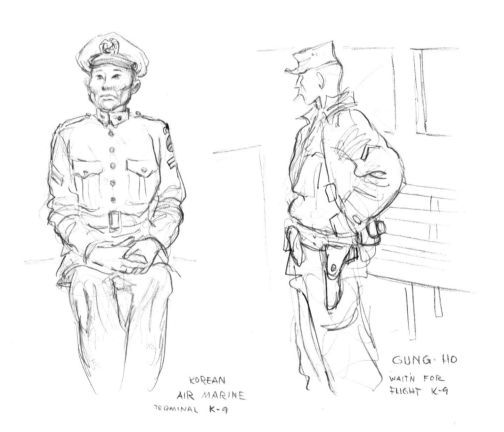

KOREAN
AIR MARINE
TERMINAL K-9

GUNG·HO
WAIT'N FOR
FLIGHT K-9

17

Sketching in Public Places

HAVING SOMETHING TO DRAW ON was and still is a major concern of mine any time I have to be seated for any length of time. In school I always had decorated the edges of my papers with running horses or airplanes. I drew cowboys and Indians all through English classes (and I have my grade cards to prove it). Sometimes it was the back of some printed program or menu or even a napkin. A business card from my billfold has served as drawing paper, and sometimes I am even fortunate enough to think ahead and have a regular sketch book . . . and maybe even a pencil instead of a ballpoint pen.

18

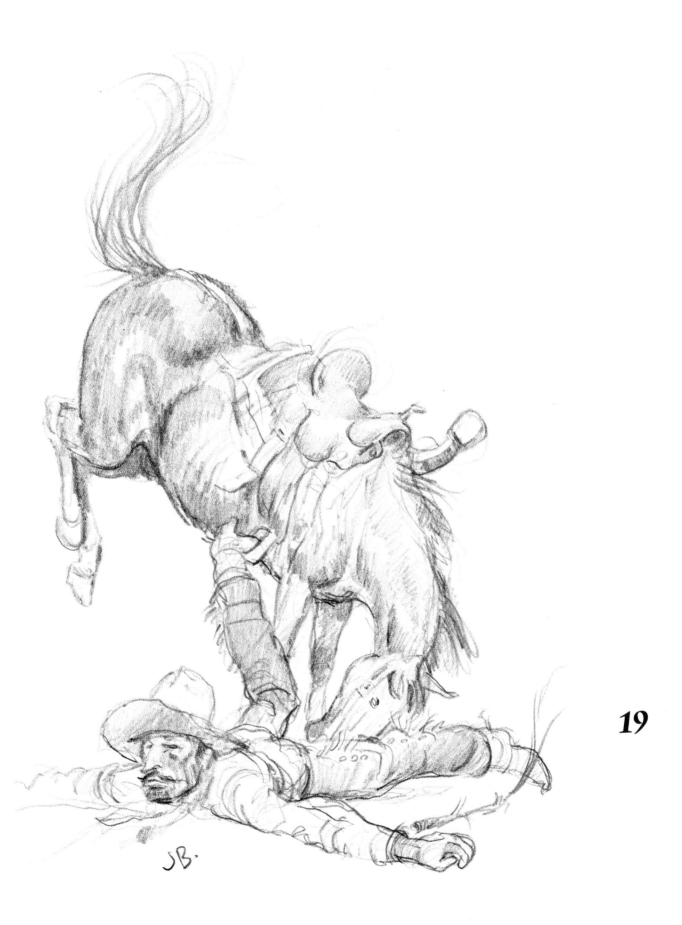

19

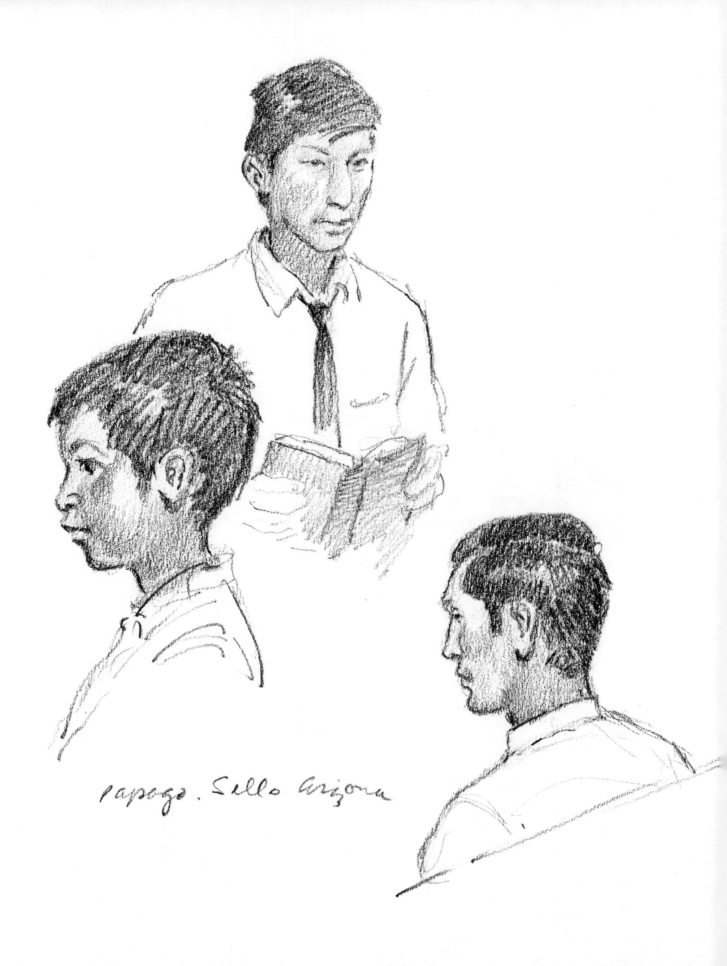

papago, Sells Arizona

The Papago boys, left, were sketched during church services at Sells, Arizona. The two musicians were friends of mine and drawn on the spot—under the light of a candle.

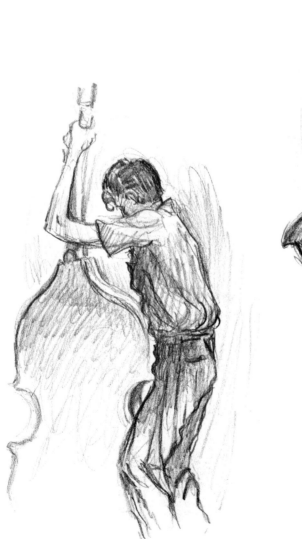

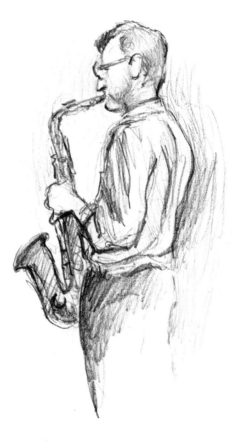

21

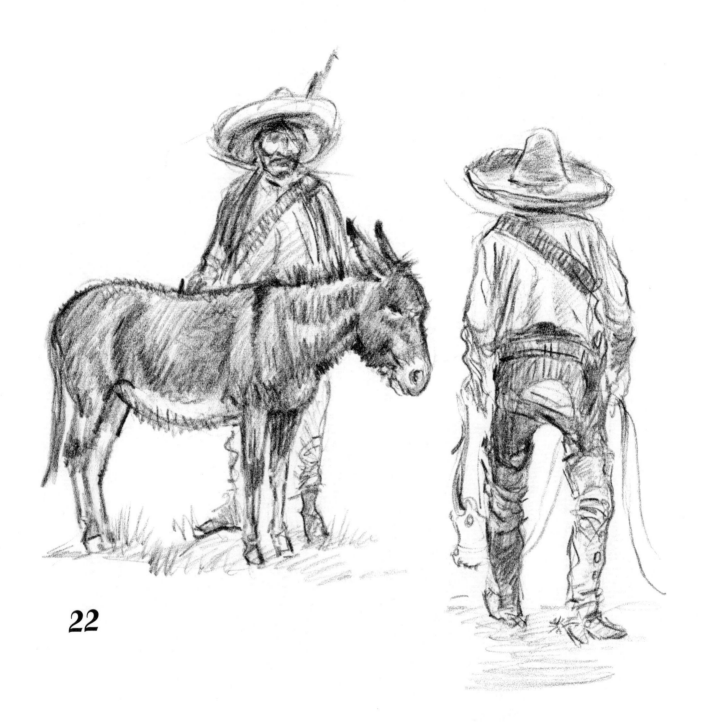

22

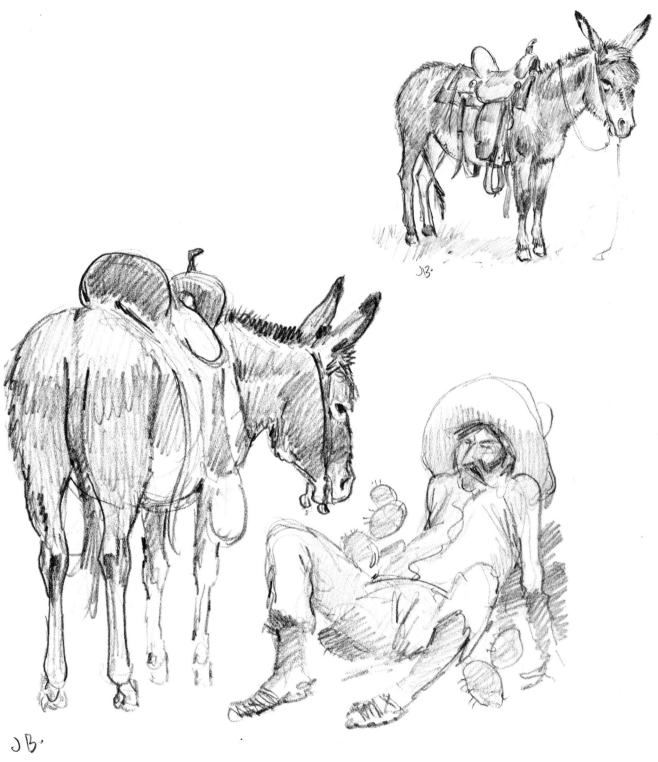

Ben Green

24

Drawing has never affected my ability to listen or to absorb a speaker's lecture, but it does make it more tolerable for me. In fact, it even seems to help me concentrate. My only trouble at times, particularly in church, is having the people seated around me give me away to the preacher by watching . . . or laughing. When our children were small and moving around and being fidgety in their seats, I found I could keep them quiet and entertained by drawing for them. Sometimes I would illustrate the sermon, other times I would sketch the people seated around us until I would make them self-conscious or nervous by staring at them.

25

This little series of characters is an illustration of what I would do to keep our kids occupied during church. I had to make sure they weren't so pleased that they would laugh out loud. Also, I would have to be careful to sharpen my pencil so that the shavings went into my boot tops and not on the floor. Our old friend, Rev. Ross Hanna of the Springriver Indian Baptist Church, knew of my habit and would sometimes right in the middle of the sermon, after watching me at work on some sketch, stop and ask me if I agreed with what he was preaching on, just to let me know he was still there. And then after church would ask to see what I had been working on and the kids would all gather around to see my Indians or my David and Goliath.

FIRST BAPTIST CHURCH
Jordan Road
February 6, 1966

| Pastor | Ira Day |
| Telephone | 232-7438 |

Sunday School	9:45 A.M.
Morning Worship	11:00 A.M.
Prelude	
Doxology *	
Prayer	
Hymn	1
Hymn	118
Announcements	
Scripture	
Hymn	20
Offering	
Special Music	
Sermon	
Invitation *	355
Benediction	
Choral Response	

* * * * * * * *

| Training Union | 6:30 P.M. |

* * * * * * * *

| Evening Worship | 7:30 P.M. |

* * * * * * * *

* Will the congregation please stand and remain
 standing for prayer.

* * * * * * * *

Music Director	Willard Hardcastle
Choir Director	Burt Emmons
Pianist	Neva Lemon
Organist	Elsa Pearcy

* * * * *

27

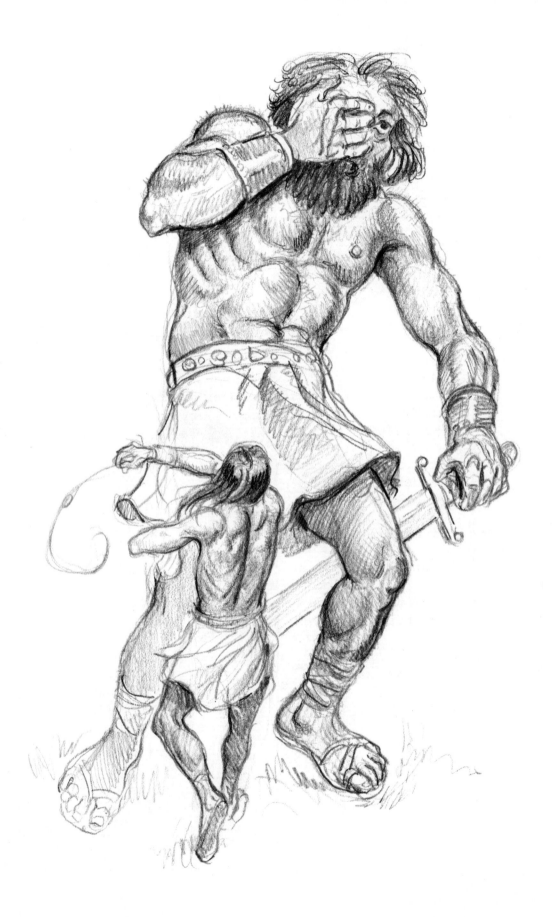

28

29

Character & Characters

I'VE ALWAYS LIKED things with character. I don't know how the dictionary defines it, but to me it is clothes, worn and wrinkled; a weather-beaten face; a good cow horse that would never win a halter class; a gunstock that shows the scars of long use and wear; and even the land and sky have character for me.

30

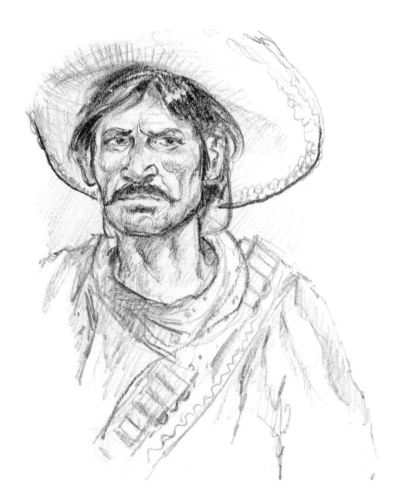

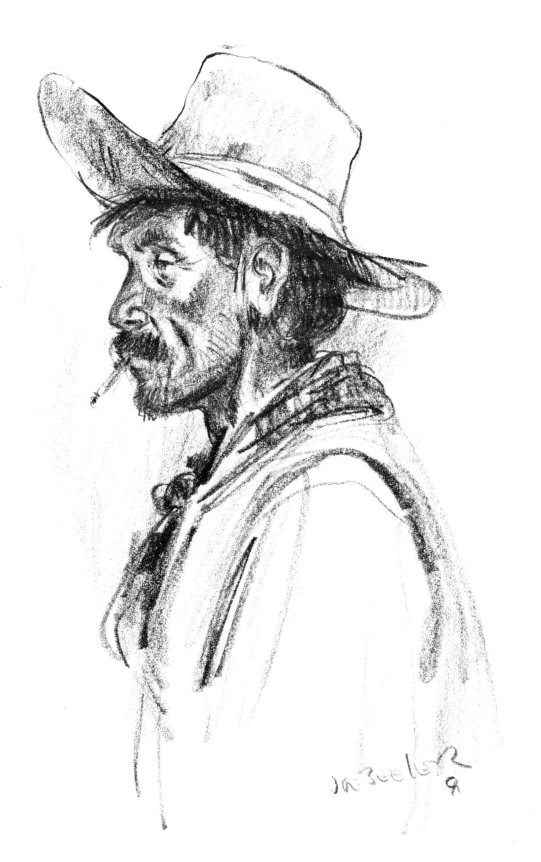

31

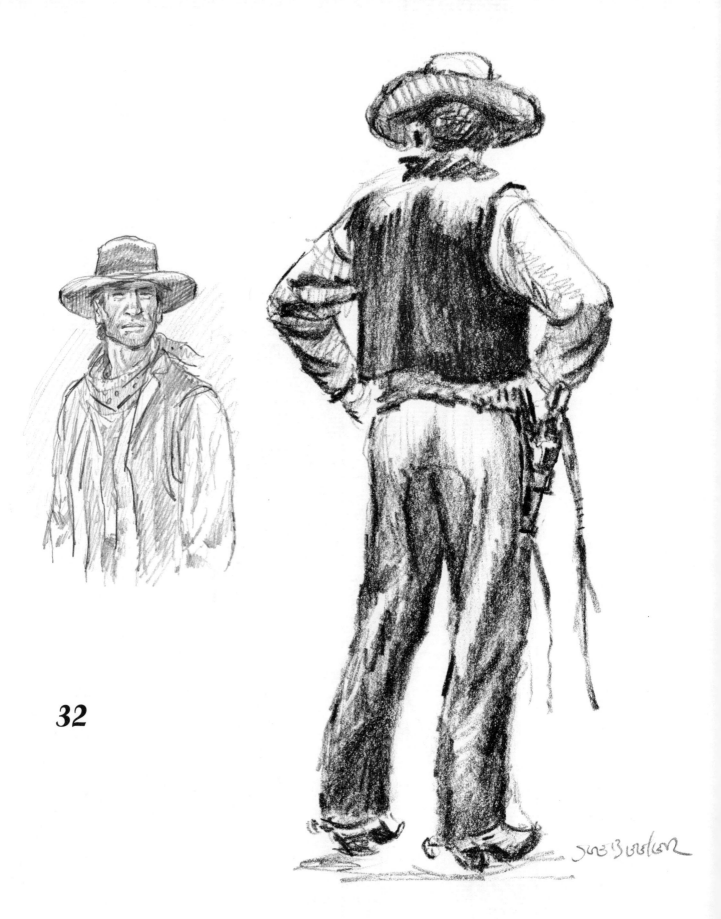

32

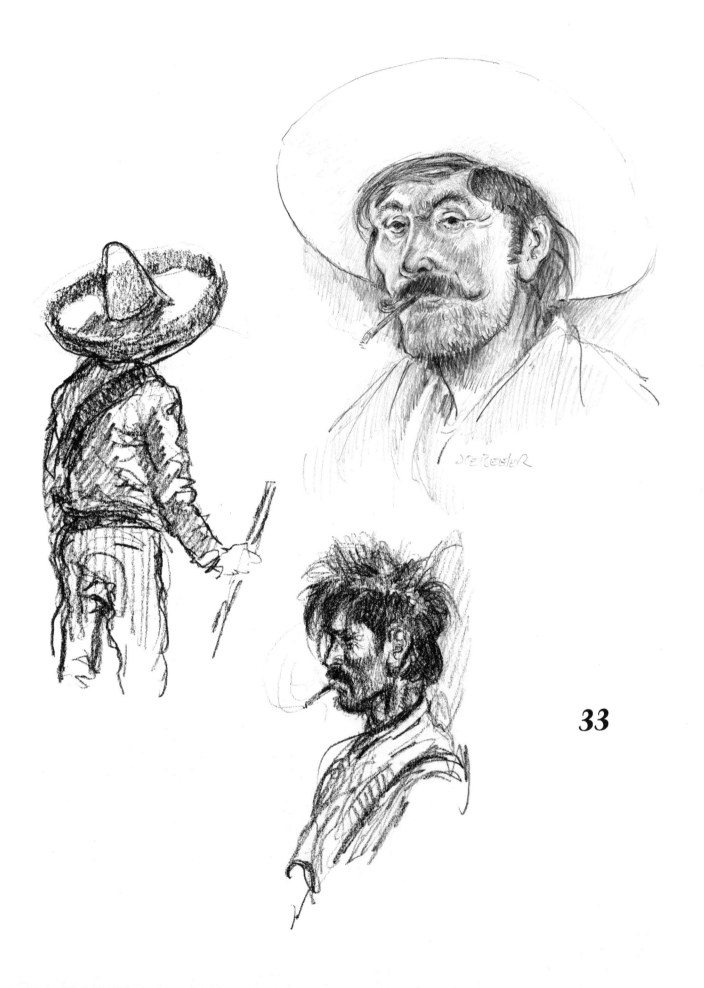

33

These two opponents were sketches
made for a larger oil painting done
several years ago.

34

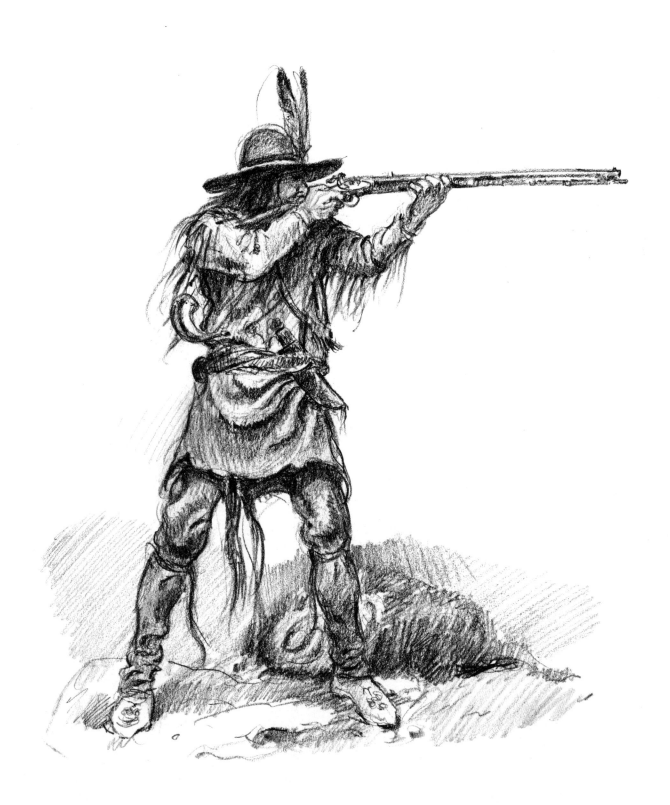

36

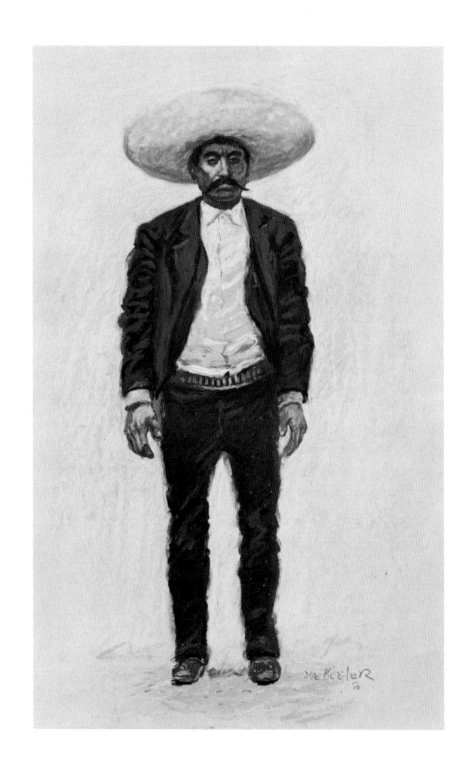

37

I have never had much luck painting women or children. They always come out looking like old cowpunchers or Indians. To paint pretty women or children, you must leave out the wrinkles and lines and any blemishes, and that's what I like to put in. It is a matter of interpretation from the artist's standpoint. Some see things completely without this character and others overdo it. Harold Von Schmidt always got character into his work and particularly, his troopers. They always looked like exactly what they were in faded blue shirts, worn and dusty. You never felt that they could be anything else. George Phippen always put this into his cowboys, evidence of work and wear, and he also got this into his horses; although they were good types of horses, they still had character. You never felt that by looking at one of Charlie Dye's cowboys that the fellow could be a banker or doctor or truck driver or carpenter . . . he was a cowboy and nothing else . . . he had that character in his work. Rodin had it in his sculpture—it is simply the way some artists see things.

38

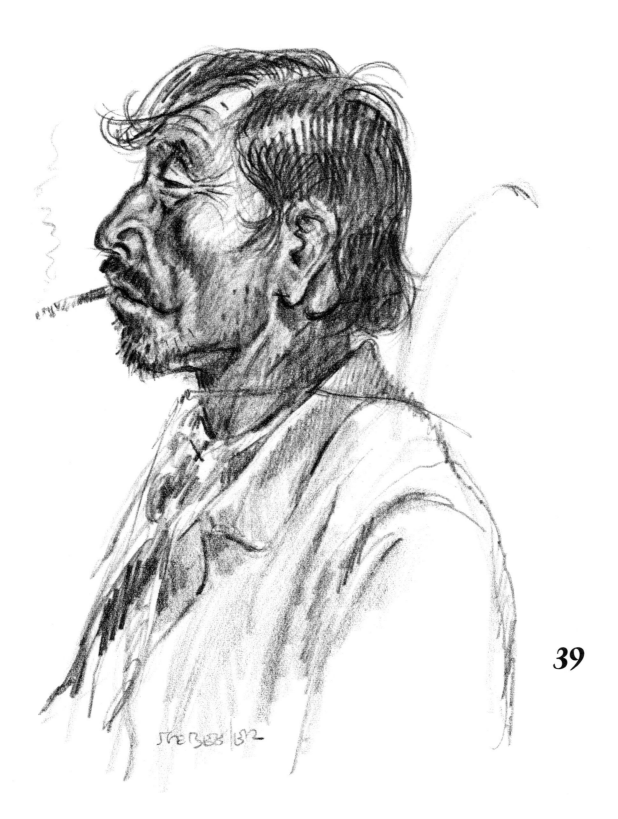

39

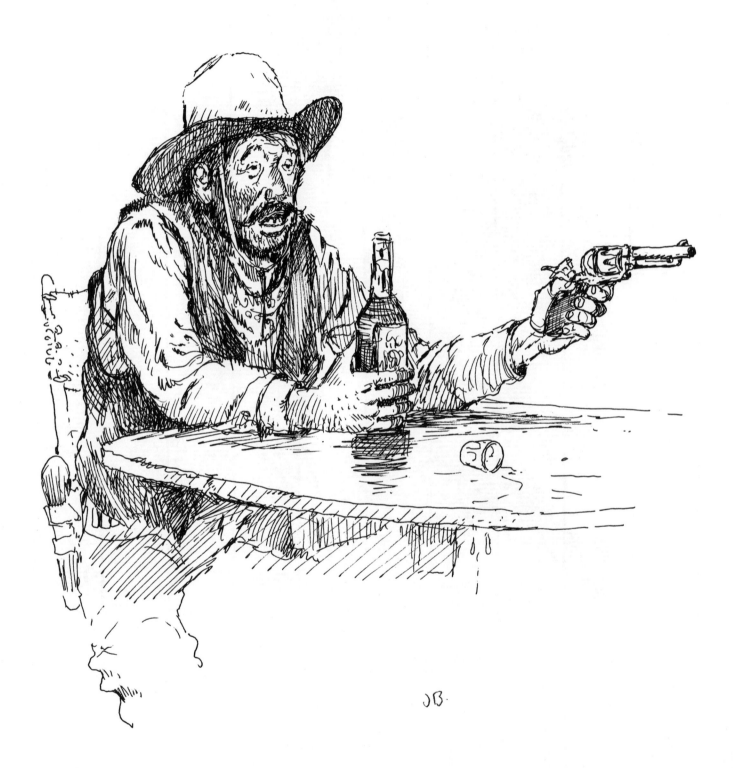

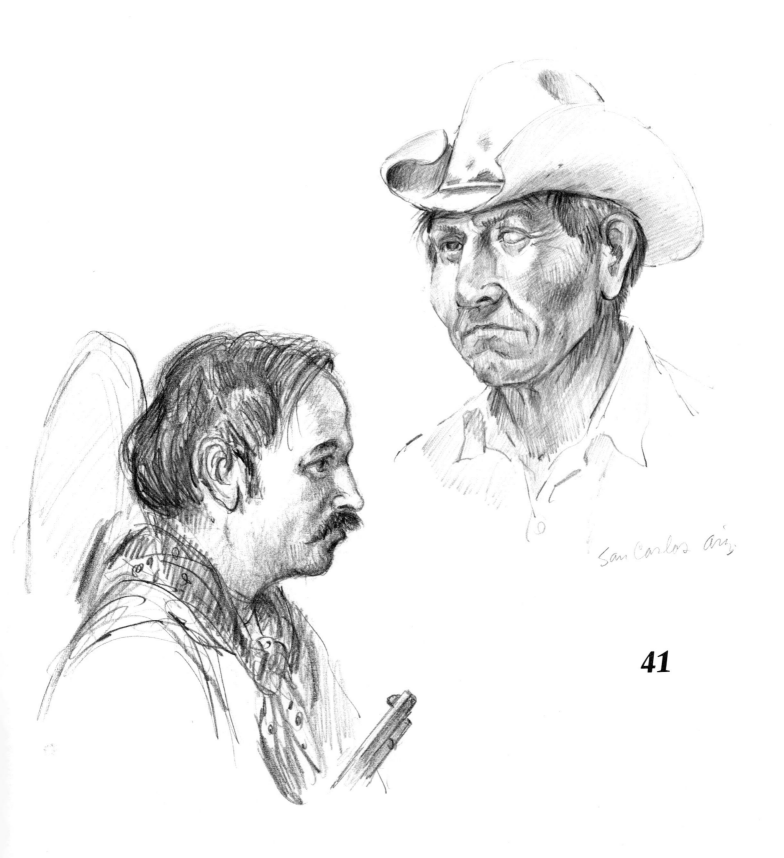

San Carlos Ariz.

41

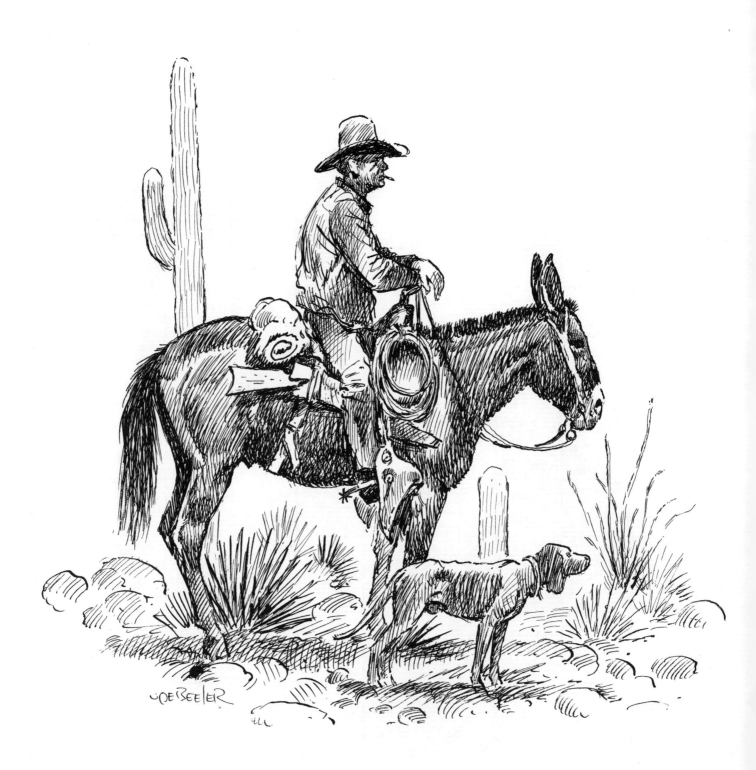

Many of the characters in this section are from life . . . one is my father, caught in his easy chair, and another is my brother-in-law as a bandit. Others are from memory. The old-timer on the mule is Claude Wright who lived and hunted in the Bloody Basin of central Arizona for so many years . . . this was done from memory at home after returning from a hunting trip with him.

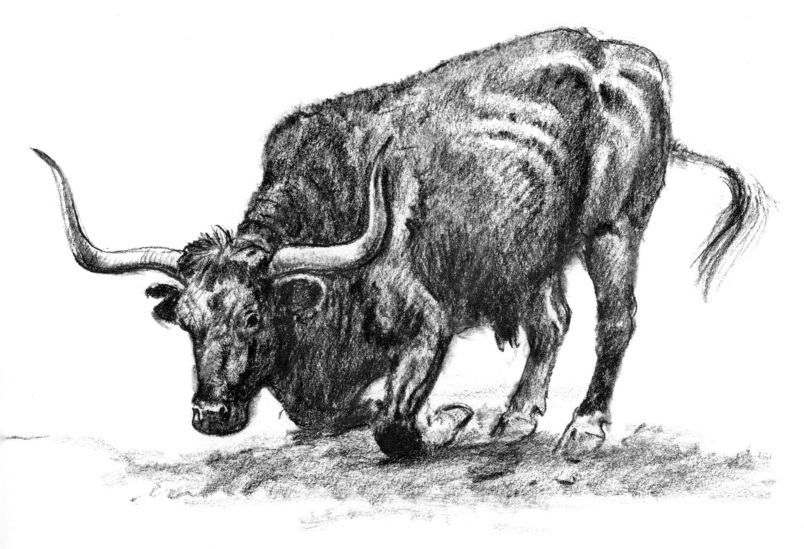

Indians

FOR DATES AND NAMES I have a rather poor memory. I cannot sit down, like many people can, and recall early years in a day-by-day fashion. Sometimes I have a difficult time recalling what I did a week ago. But I do have certain moments burned into my memory, highlights that are still very vivid to me. One of these was when I was no more than four or five years old and with my mother and father on a 4th of July. It was at the Quapaw, Oklahoma powwow at Devil's Promenade. I can still see all the bright colors and hear the sounds of that day. The pulsating beat of the drum; the singing and the sound of the dancers with their bells keeping a constant rhythm of the songs. The seed was planted in me early for the love of the Indian way of life.

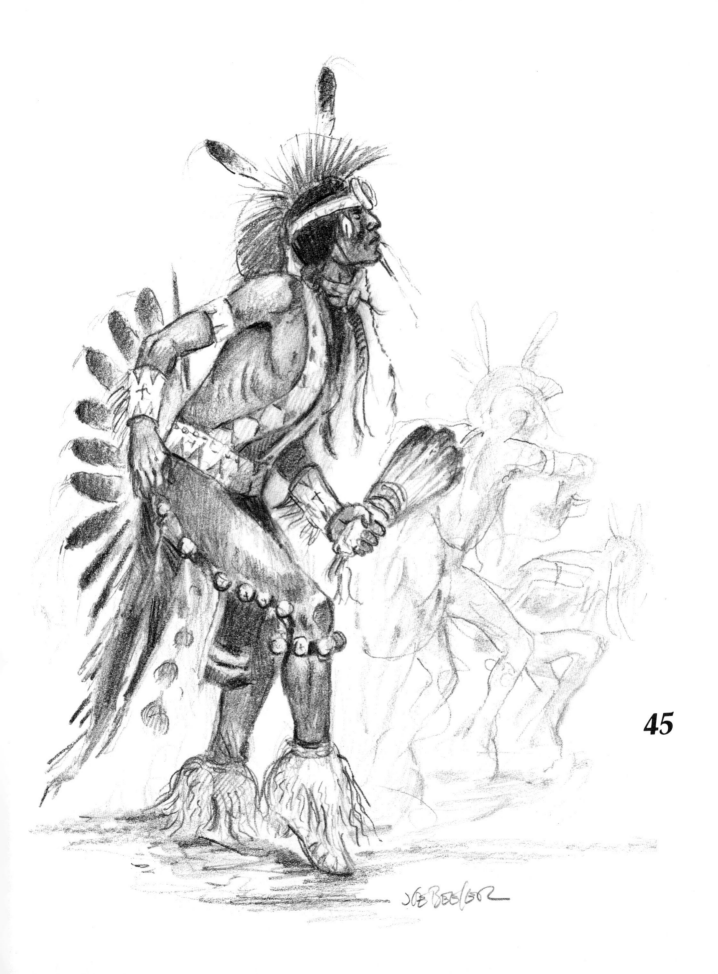

45

I drew about all the famous Indians I had ever heard of or read about. Geronimo was one of my favorites; I did a lengthy series of drawings about his life in a comic strip style. I spent weeks and months on this project and was further inspired by tales my uncle told me from his experiences at San Carlos where Geronimo had lived in Arizona.

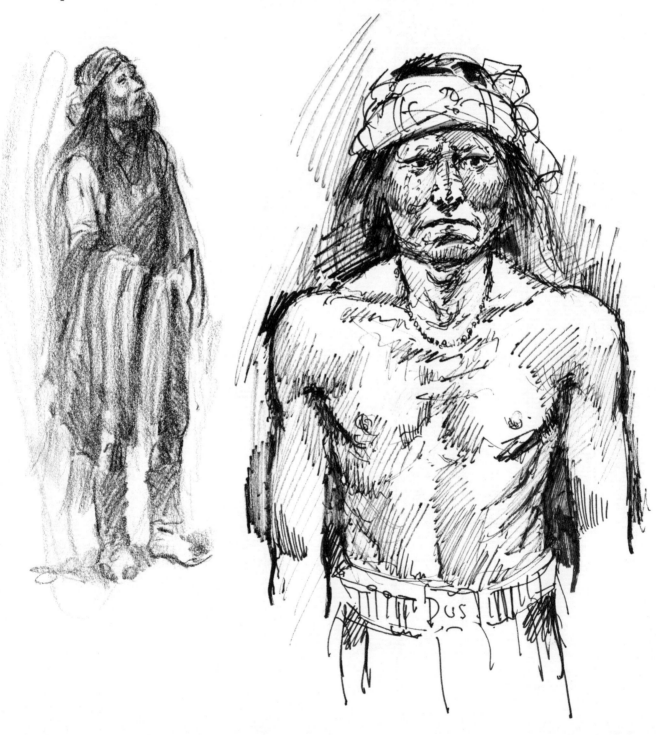

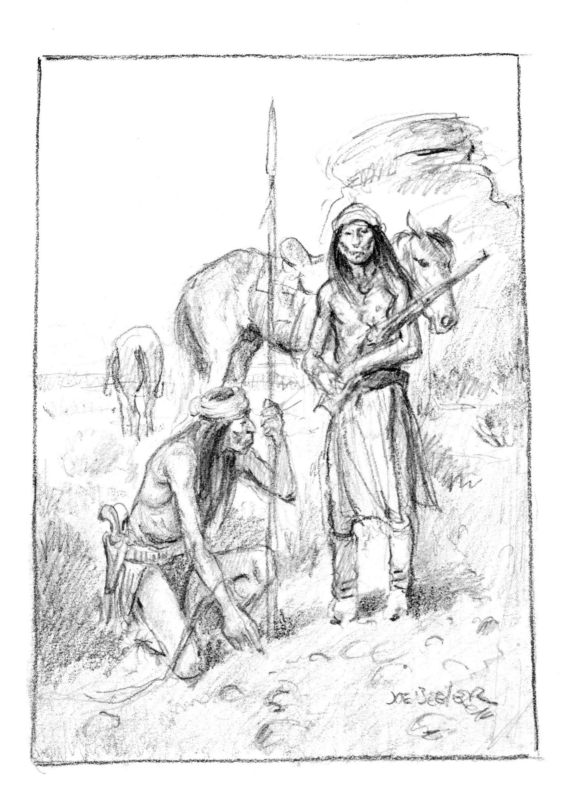

47

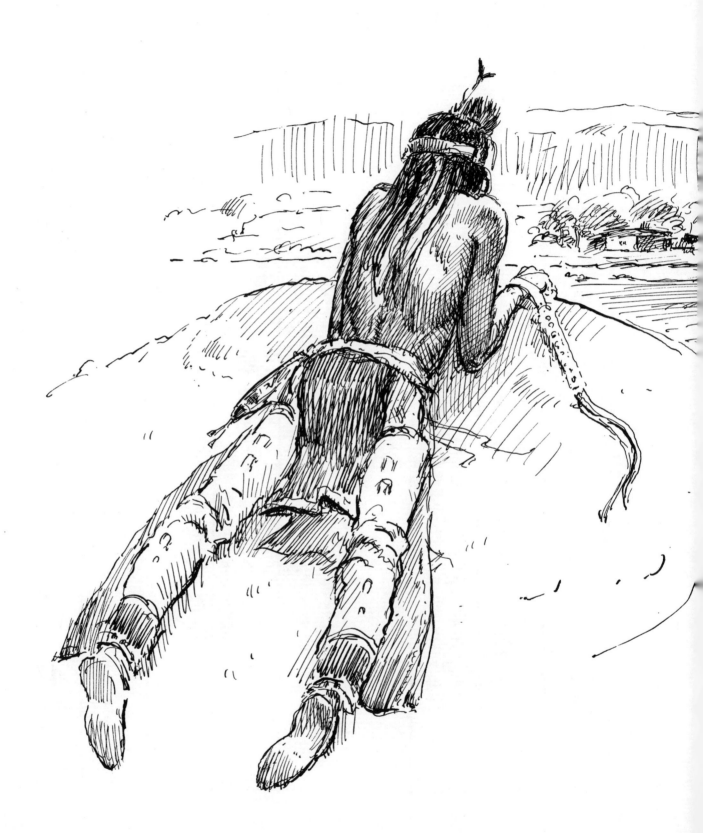

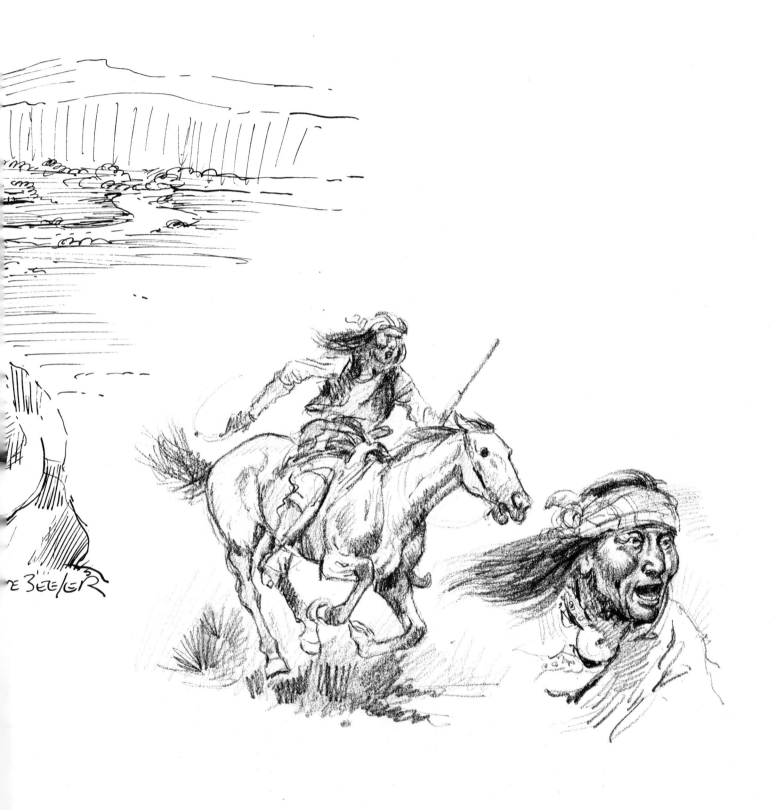

The Cheyenne, standing at ease, is a contrast to the action on the opposite page of the Apache crown dancer done at San Carlos, Arizona.

50

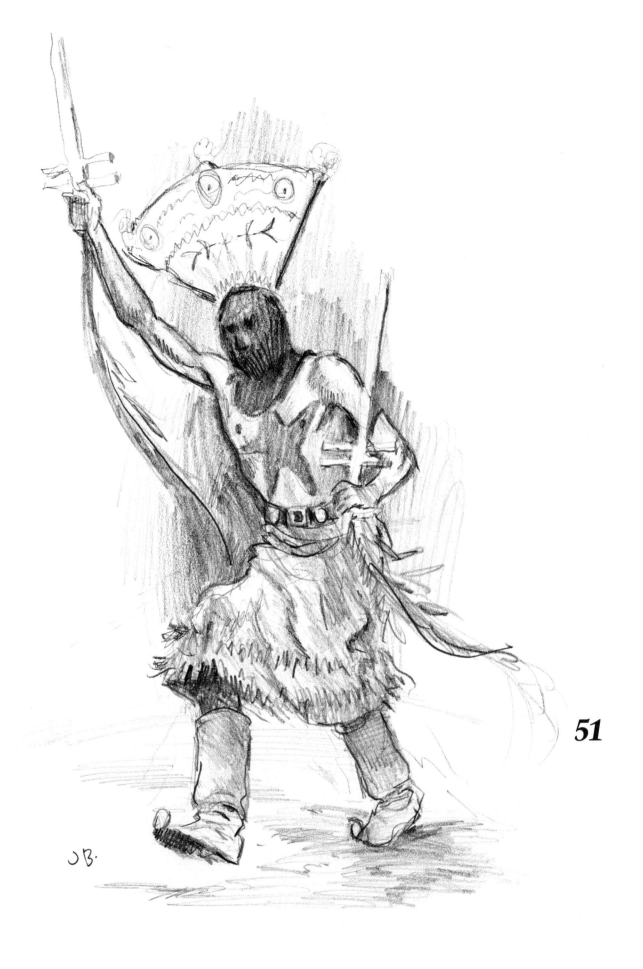

51

This proud fellow is a Pawnee
straight dancer, sketched years ago
during the Fourth of July powwow
at Quapaw, Oklahoma.

52

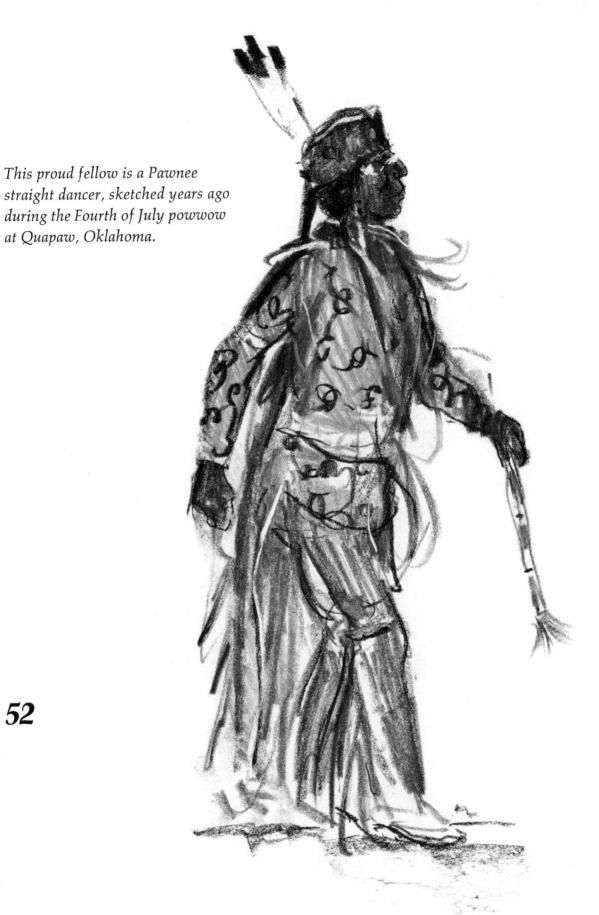

In my teens I got a real taste of Indian life. We were raised to be proud of our Cherokee ancestry from my father's side of the family . . . mixed of course with an assortment of German, Irish and a couple of other European varieties. But I was more Indian on the inside than the outside. I had always wanted to dance, but the thought of my white legs gleaming from underneath all the fine beadwork and feathers made me laugh, and I was sure others would too. One July during the Quapaw powwow, my old friend, Louis Ballard, a Quapaw-Cherokee with great personality (and now a fine teacher), approached me with a proposition. This year he was going to dance as a clown, John Turkey Legs, and had a get-up to go with it where not even his own mother or brother knew who he was. He usually danced in a traditional war dance costume, and since he wouldn't be using it, he asked me to take it and dance. It was a fine dance suit with eagle bustle and loud-colored plumes to touch it off. The dance harness and cuffs all were matching beadwork, and it was topped off by a fine, colorful roach. I took him up on the offer and danced the rest of that powwow. I learned many of the songs, for to dance you must know them or you will still be dancing when the drummers have stopped, and this will set you apart from the others a lot more than the white legs. From then on we made as many of the powwows as we could get to, and I danced at all of them. I enjoyed all the fun and benefits of the powwow life that my full-blooded friends did.

53

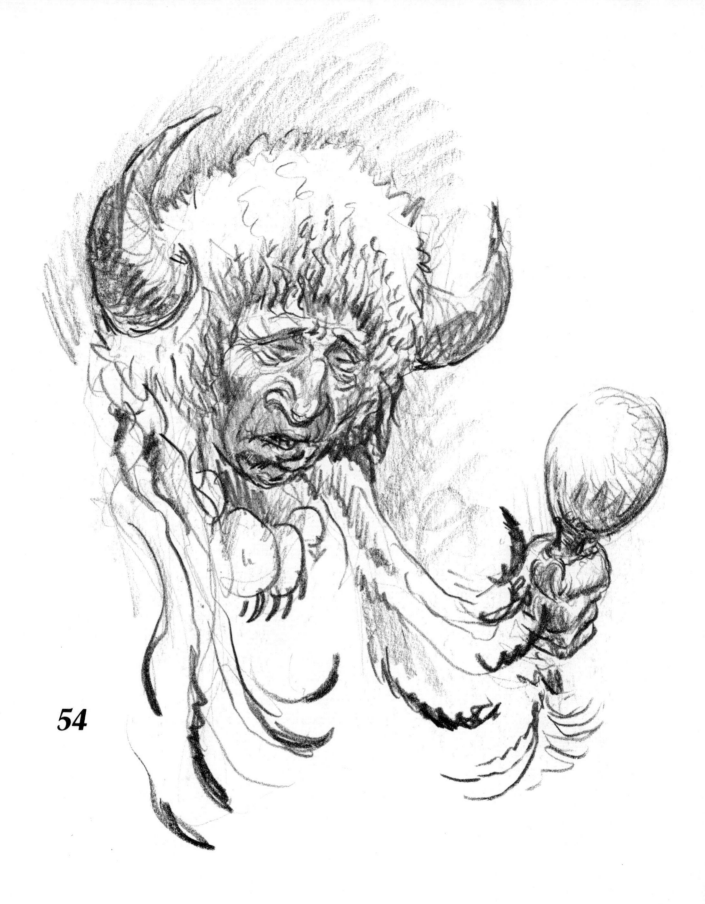

54

We would pool our money for gas, load up and take off to the powwow we thought would offer us the most fun. I never carried a sketch book then . . . I was too busy having fun and eating to worry about drawing. Eating has always been a preoccupation at powwows. We had it figured out in true Indian fashion to always appear at someone's camp at mealtime. We never slighted anyone's cooking, and the better cooks were rewarded by watching John Lee, Louie, Jake, Phil and myself clean up our plates to where you could see yourself in them. Indian people have always been very hospitable where guests at their table are concerned . . . everyone is welcome, and you share what they have cheerfully. Drawing about the things I have done and seen was the fun I had after I got home.

This kind of growing up gave me much valuable knowledge for my work that was yet to come. I became aware that there were not only cultural differences between the many tribes, but also there were great physical differences as well. A Creek did not look like a Cheyenne, and a Shawnee did not look like a Kiowa. The two basic divisions of the many Indian peoples in Oklahoma are the Woodland Tribes and the Plains Tribes . . . here is where the cultural and ceremonial differences vary a great deal. I have been around them and drawn them all.

56

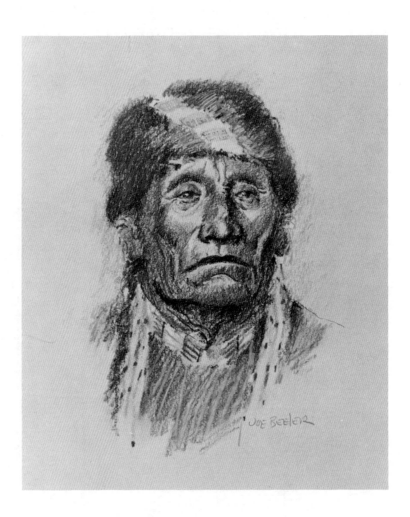

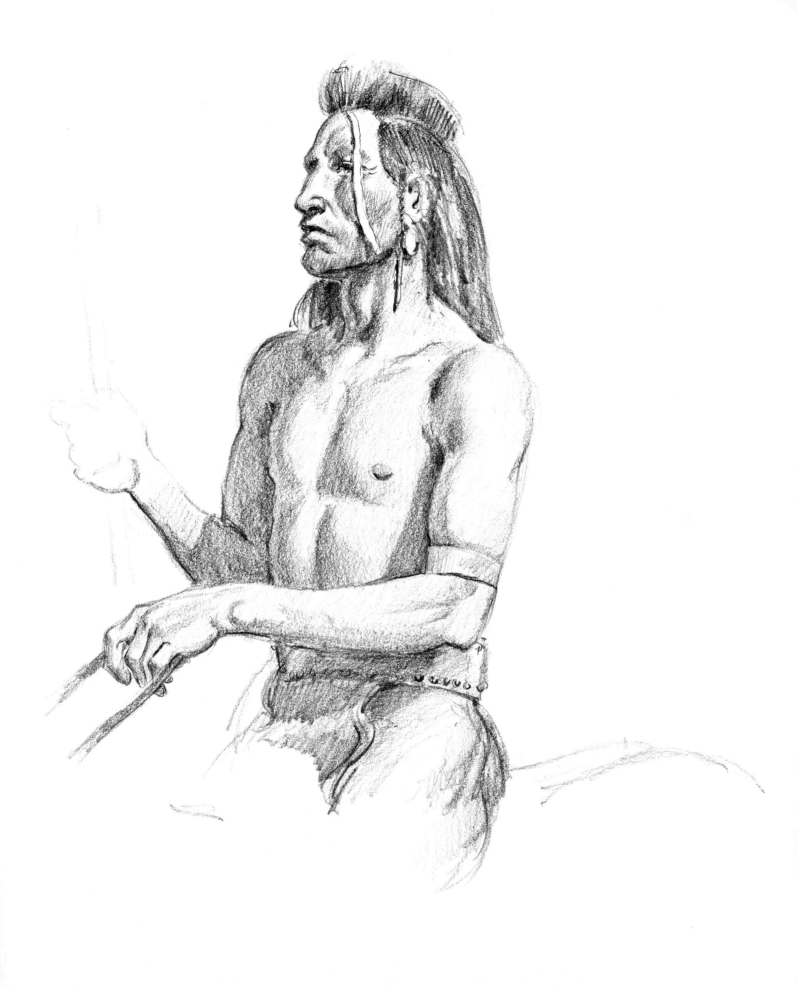

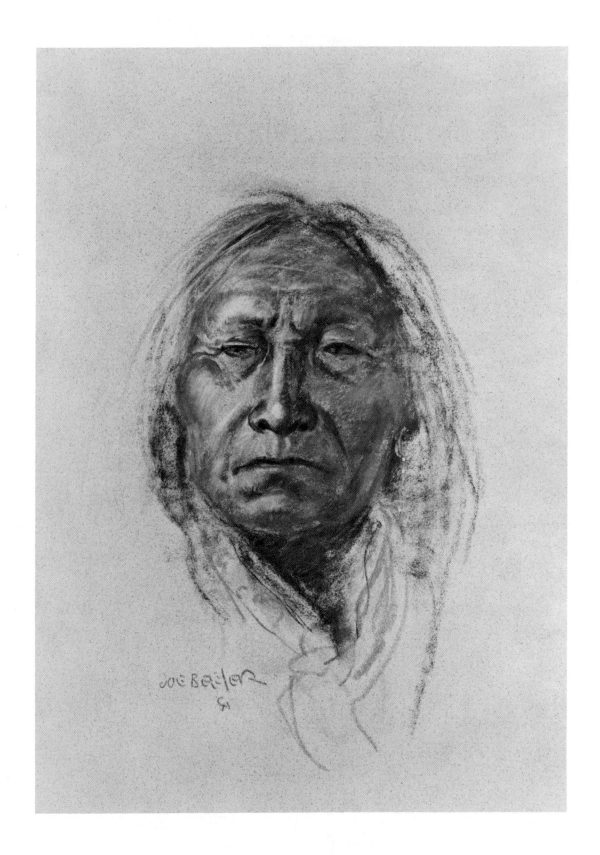

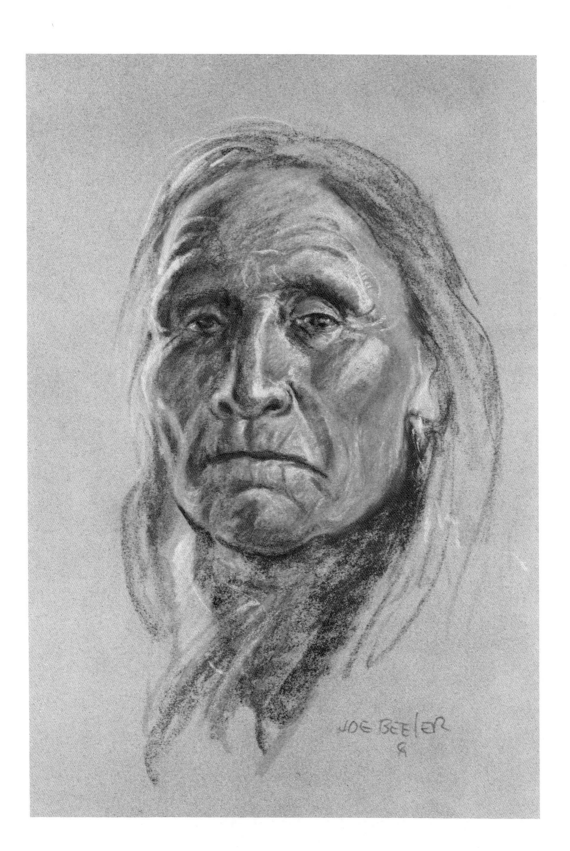

Since most of the paintings and bronzes I do are of an historical
nature, great care has to be taken when portraying a particular tribe.
Understanding and care have to be given not only to an Indian's
costume and hairstyle but also to his physical characteristics. An Indian
moves differently than a white man, and he also sits a horse different
. . . it is difficult to describe, but if you study this you will see. So often
in a western movie you will see a bunch of yelping figures coming off a
hill, and you don't have to see their hairy legs and arms to know they
are not Indians . . . and then again you may see one where the director
has been careful to make his story authentic. He has used Indians for
Indian parts in the movie, and you see them dashing along on a
bareback horse, yelling and firing, and it just looks right. It is the same
in art . . . being able to paint a naked figure on a running horse with
stringy, black hair flying and wearing a beaded belt and moccasins is
not enough to call yourself a western artist.

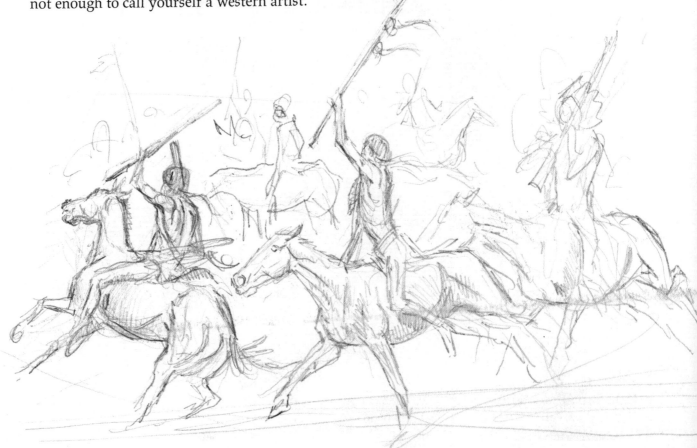

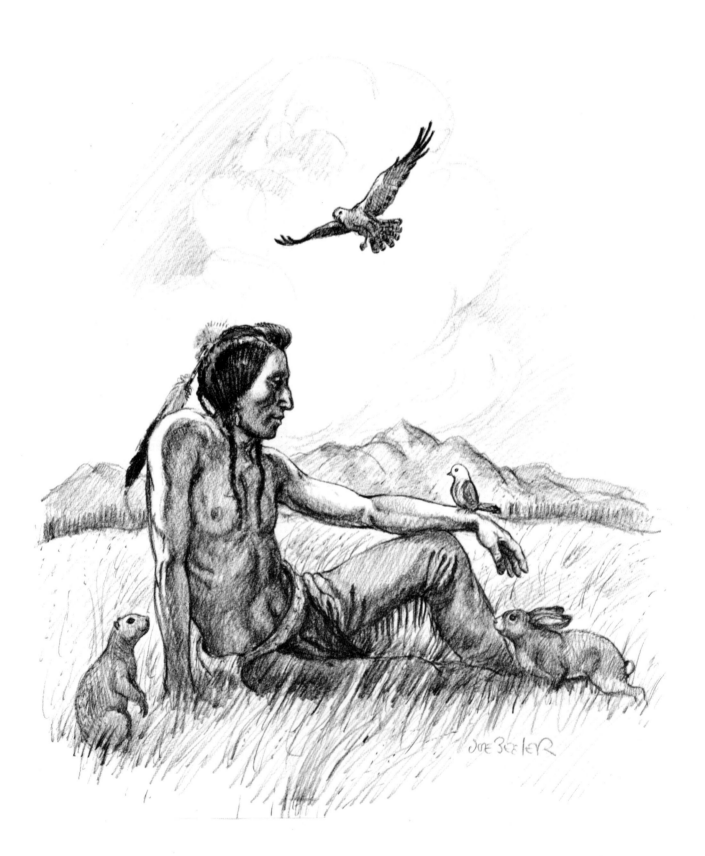

62

Comanche

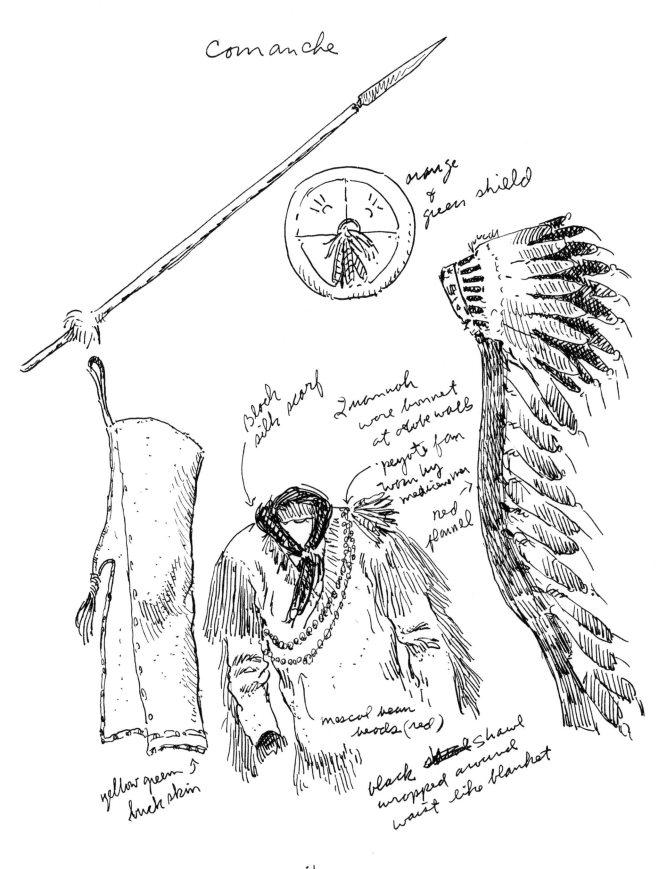

orange & green shield

Black silk scarf

Quanah wore bonnet at adobe walls peyote fan worn by medicine men

red flannel

mescal bean beads (red)

yellow green buck skin

black ~~silk~~ Shawl wrapped around waist like blanket

Red mesquite Bean necklace.

The Modern Cowboy

THE COWBOY in this sketch, pullin' leather, is me. This was just one of the hazards I experienced when I went over to the Apache Reservation at San Carlos, Arizona, back in 1959 to do research on these Apache cowboys. They have a big cattle operation and it still has the flavor of the old-time cowboy way of life, and I wanted to see and experience some of it. The horse in the sketch had been wanting to buck all morning. We were passing through a large series of wooden catch-pens, and he broke in two with me, bucking through several of the Apaches, and we finally came to a halt at the far end. My friend Milt Foreman, the white stockman for the outfit, was there, and he told me to step off, unsaddle and change horses with him, for he didn't want to have the blood of an artist on his hands. Well, I said OK and did what he said; then he told me, "The one you've been riding wasn't supposed to buck, but this brown gelding I just traded you will." I said thanks, rode off, and the brown gelding and I got along fine the rest of the day.

64

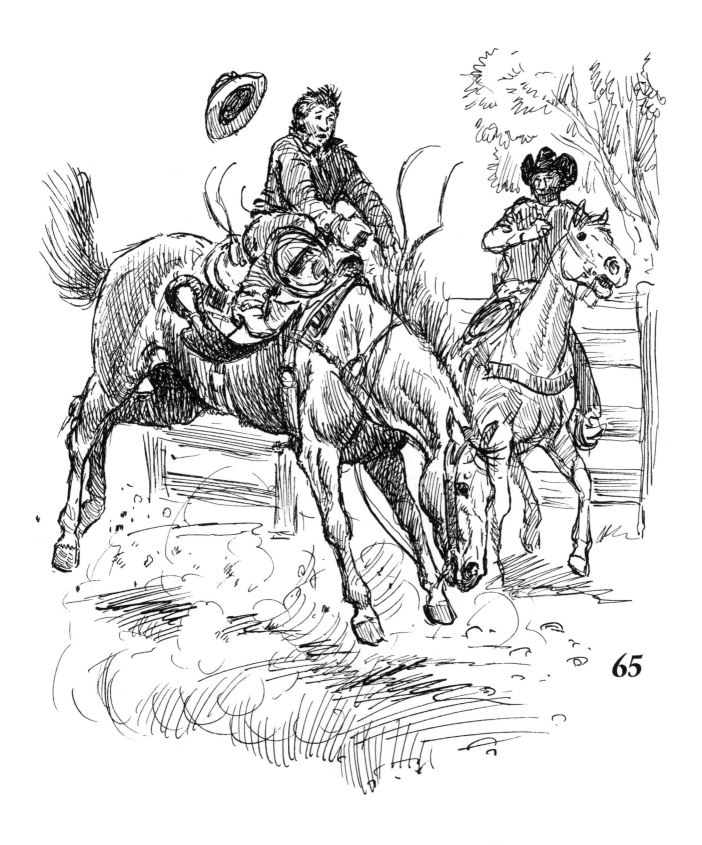

65

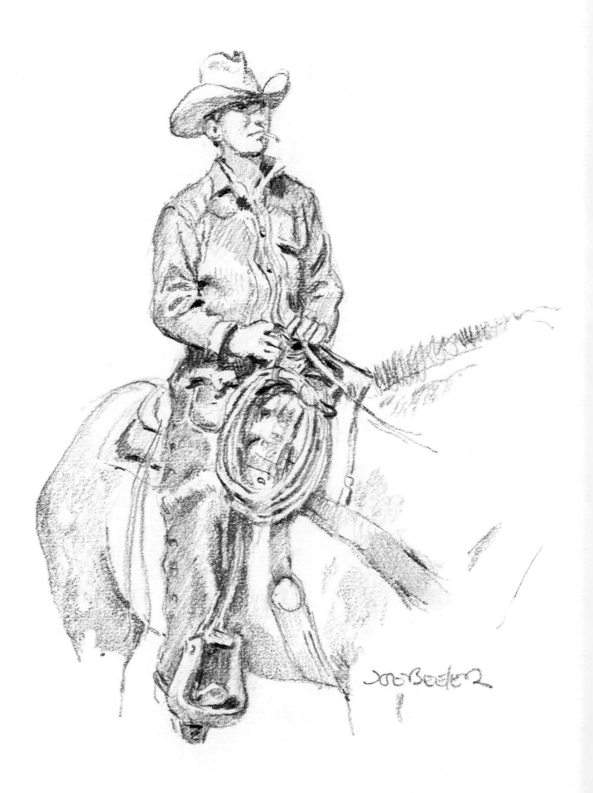

66

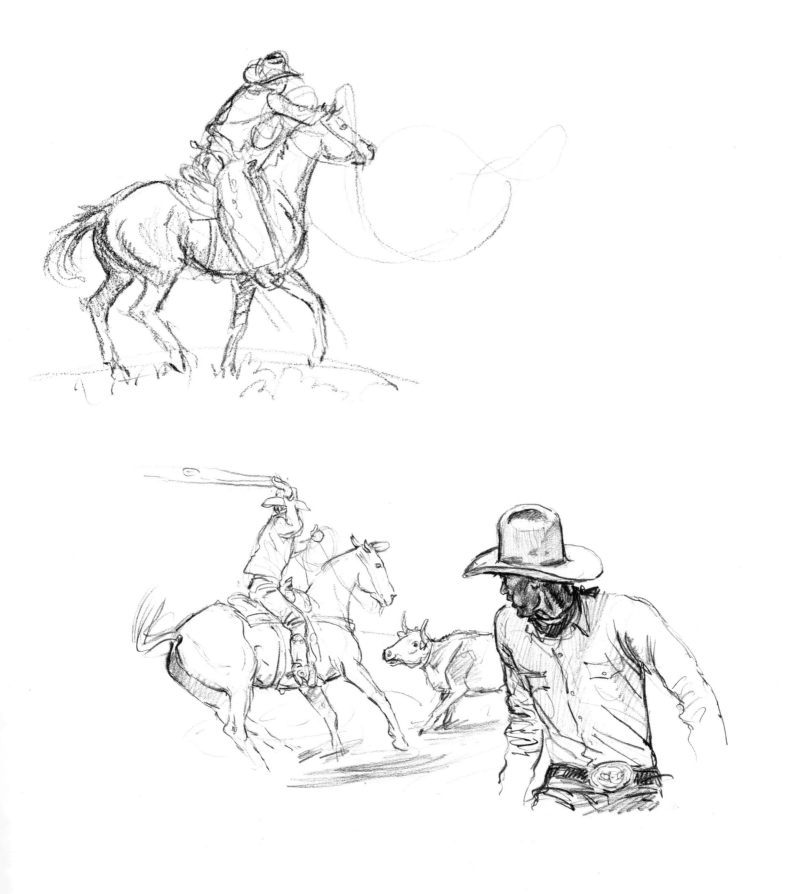

Although much progress in the cattle industry has come about in the past 100 years, the cowboy is probably the one workingman in the country whose basic tools and philosophy haven't changed much. True, you may see a cowboy in a pickup truck, airplane, or helicopter, but when you get right down to business, he forks a pony and with rope in hand and chew in mouth gets the job done just the way his father and grandfather did. The cowboy is colorful in dress, speech and mannerisms and prides himself in holding to the old-time traditions. Why wouldn't he then be the target for so many contemporary artists?

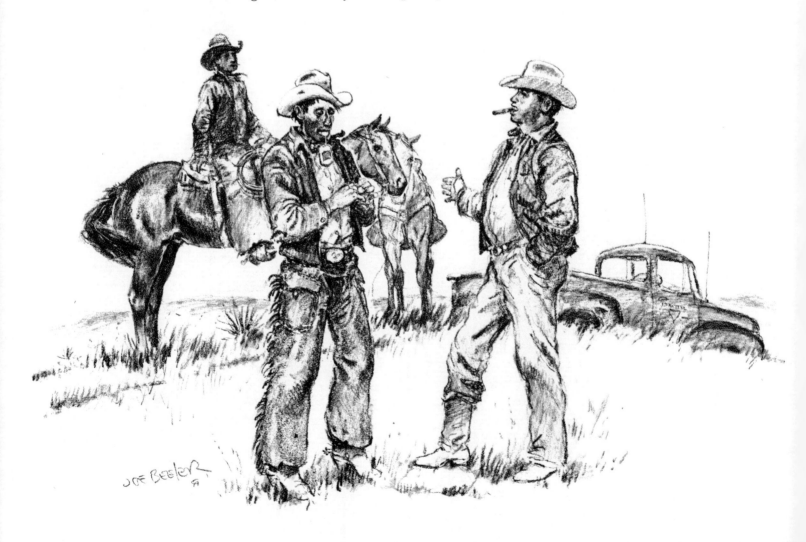

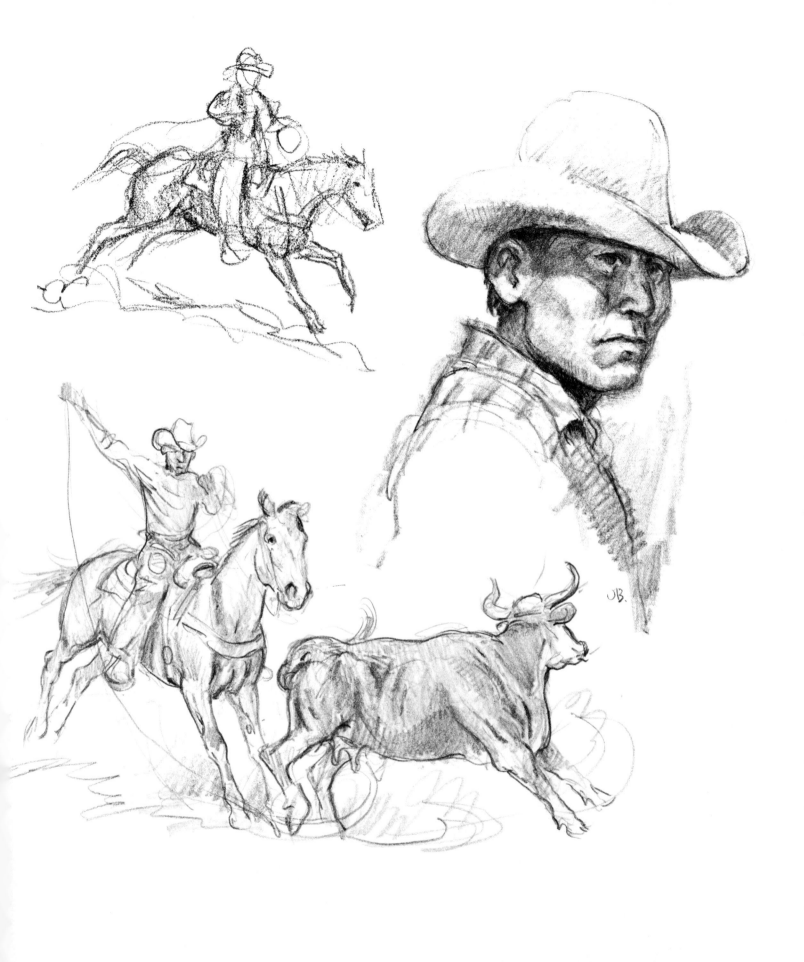

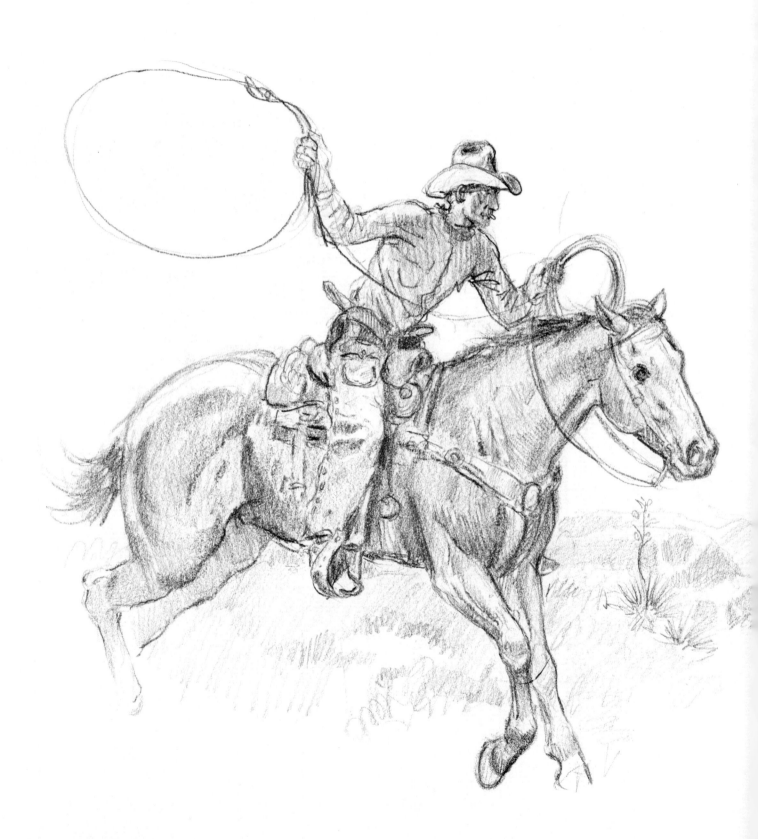

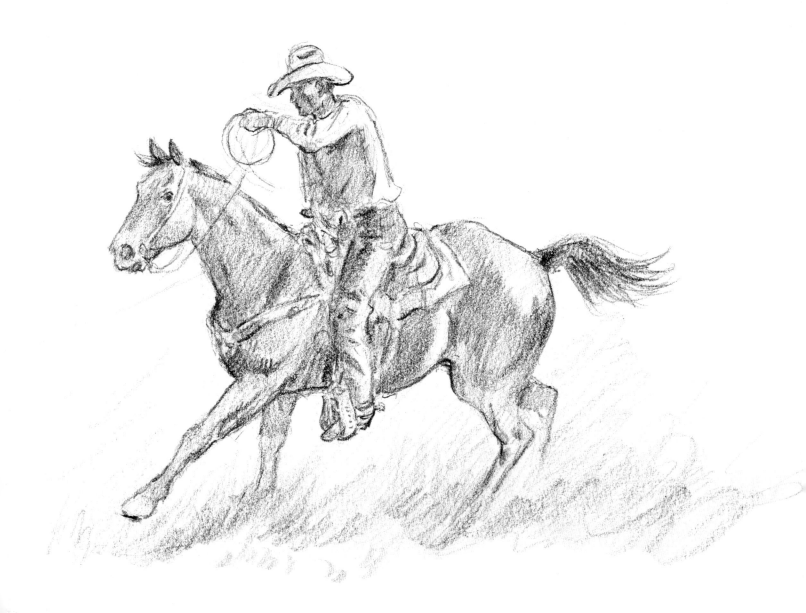

71

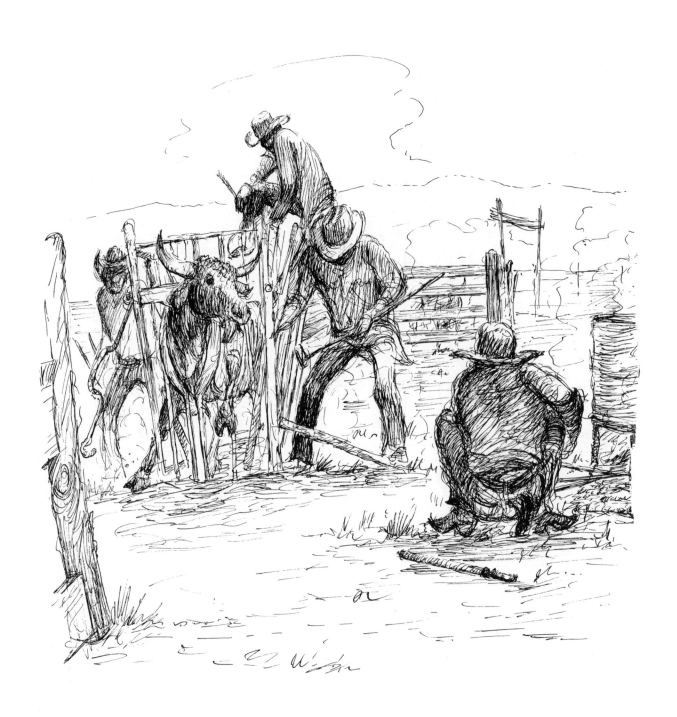

BRANDIN TIME - CHANDLER ARIZONA
1949

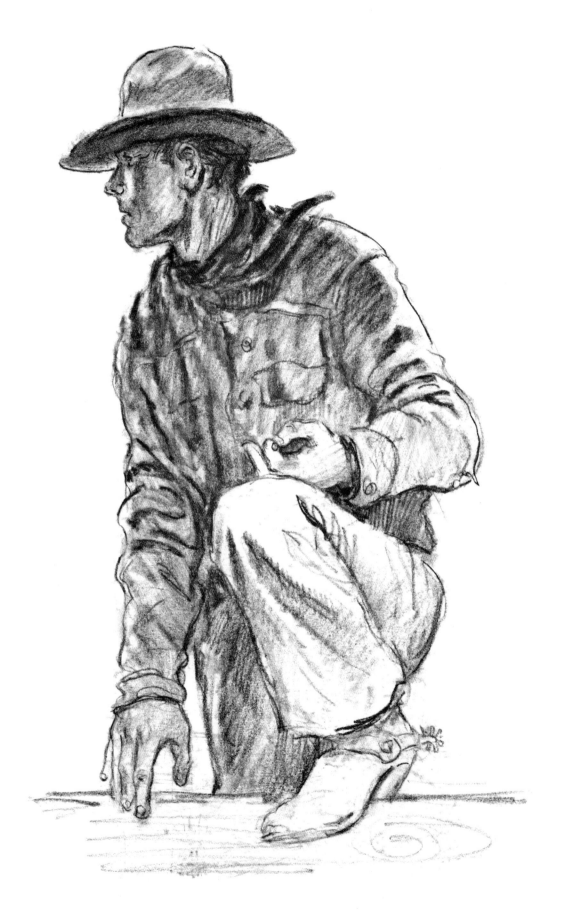

73

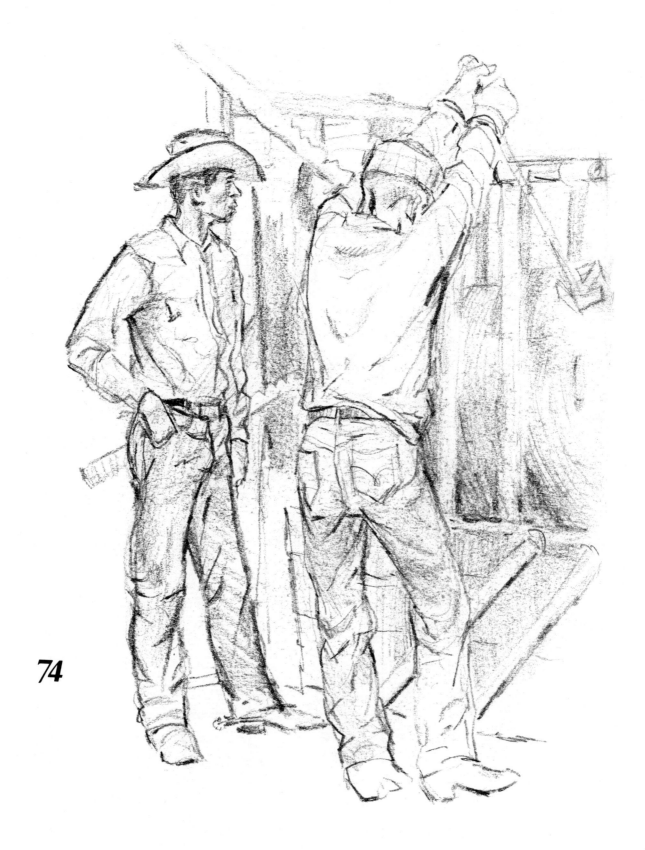

74

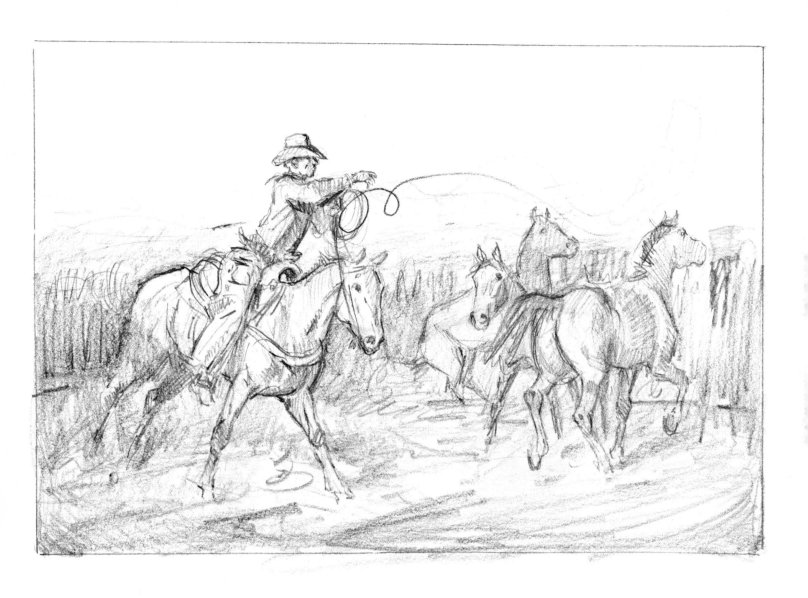

75

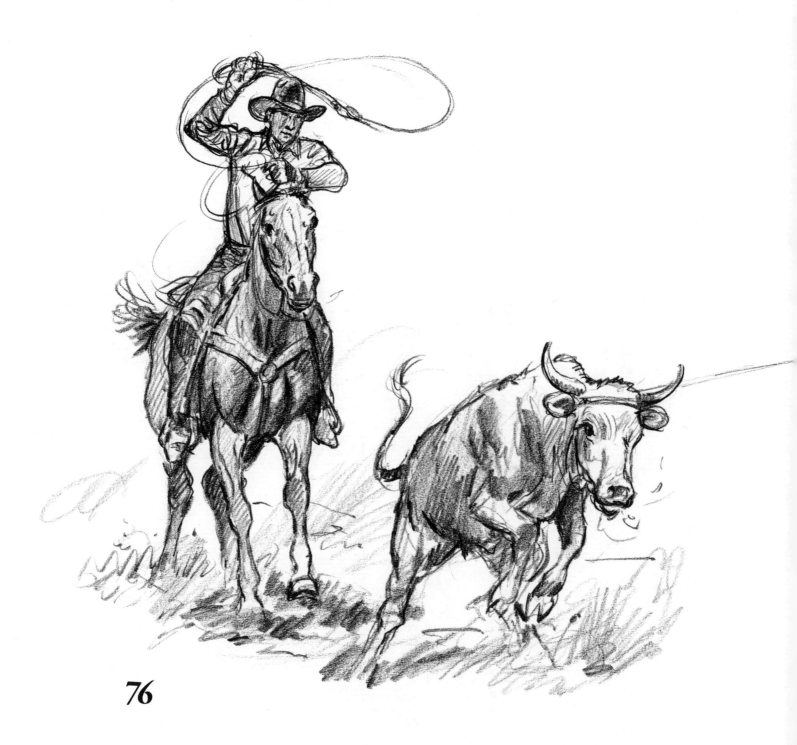

76

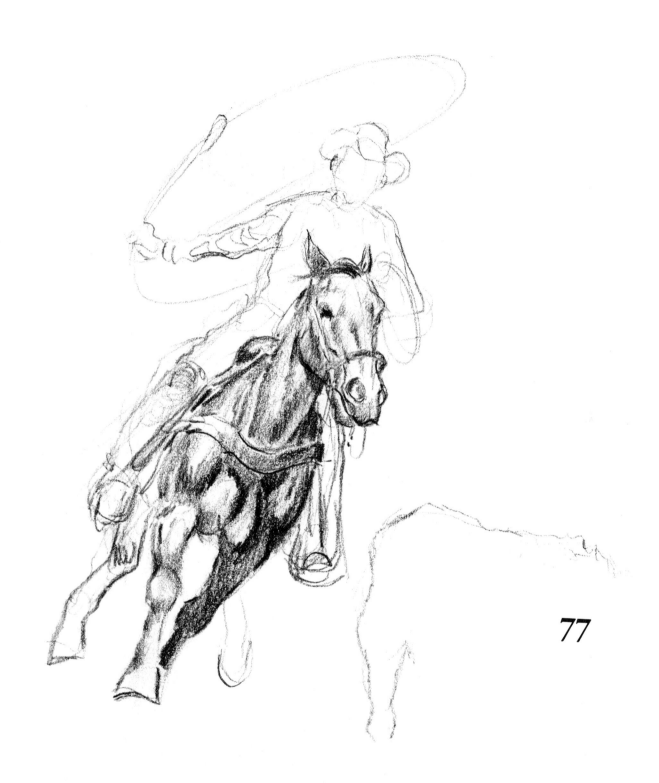

77

Most cowboys are stylish dressers by their own standards with a liking for good quality boots and hats and other articles of clothing. Their needs originated from being outdoors and doing their work off the back of a horse. But today cowboy dress has become an American way of dressing whether you live in the West or not and whether you own a ranch or just one horse . . . or no horse at all.

78

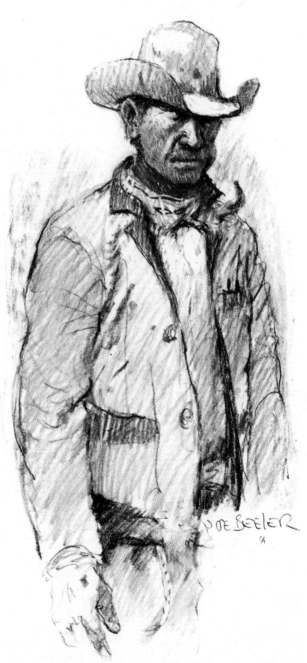

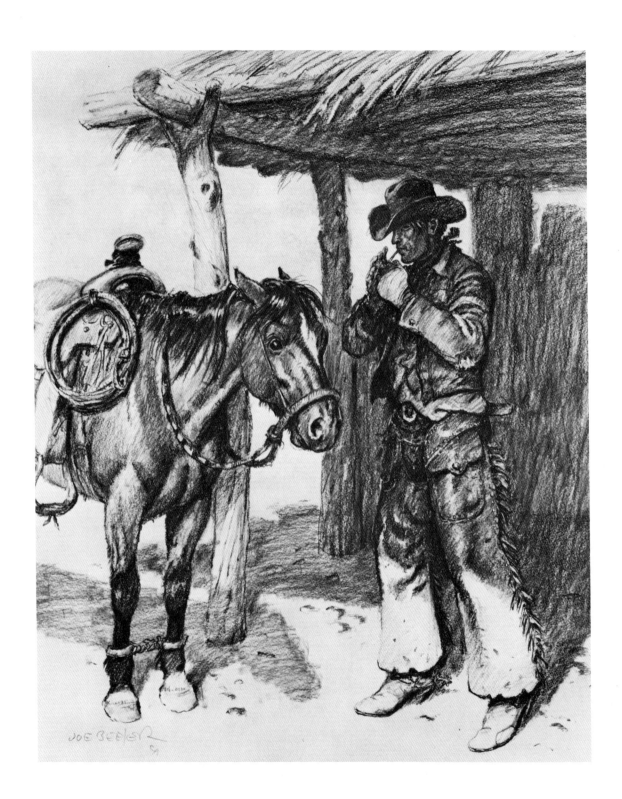

Although the cowboy's dress has been traditional for many years, I sure got a shock a couple of years back. My roping pardner from here in Sedona, Ed Wright, and I had entered the team roping at a rodeo being held in Wickenburg, Arizona. When we pulled in, we immediately saddled up and rode around to begin warming up our horses. We saw many familiar faces, other ropers, etc., but all the bull and bronc riders were young college-age boys. We couldn't believe how some of them were dressed. We were used to seeing long-haired hippie types around, but *cowboys?* I finally figured out that these guys have to really be tough to come to a rodeo lookin' that way. And sure enough, they were. One guy who we had been watching was really a dandy, flowers sewed on his pants, long-haired mustache, turtleneck sweater and over his long locks, a baseball cap. When the bulldoggin' started, he was the first one out of the box. He drew a tough steer, but when the dust settled, he had him on the ground in five seconds flat. And that's the way it went in all events for the rest of the rodeo. All the funny-dressed, mod cowboys were sittin' in the lead. Ed and I were both convinced that if it would help our ropin' much, we were goin' home and have our wives embroider flowers on our Levis, grow our hair long and start wearing open-toed boots.

80

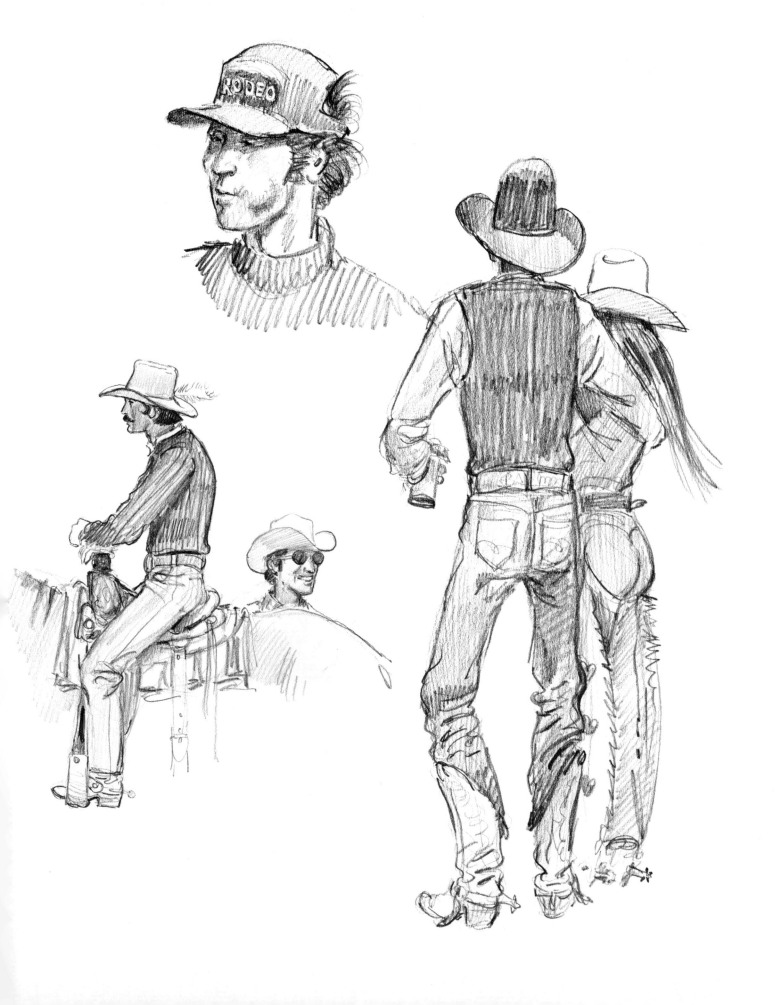

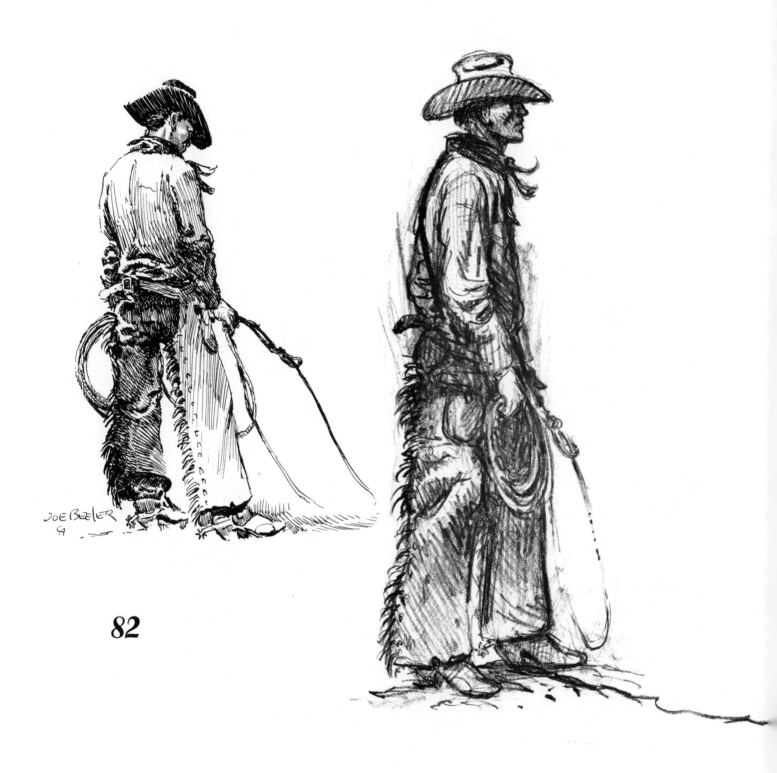

82

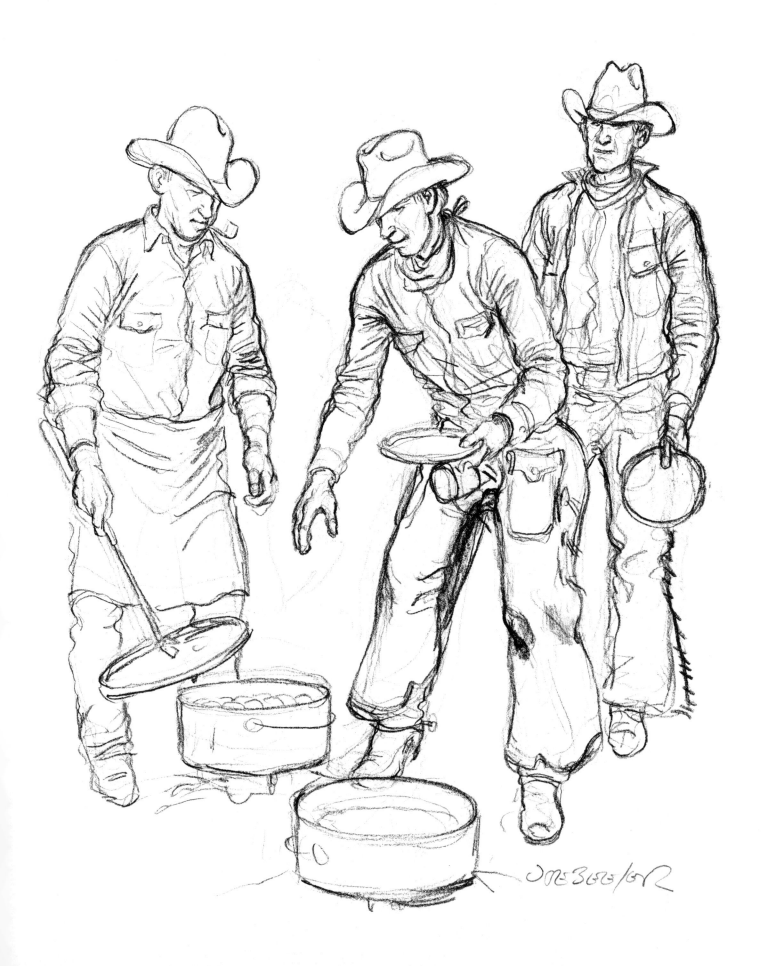

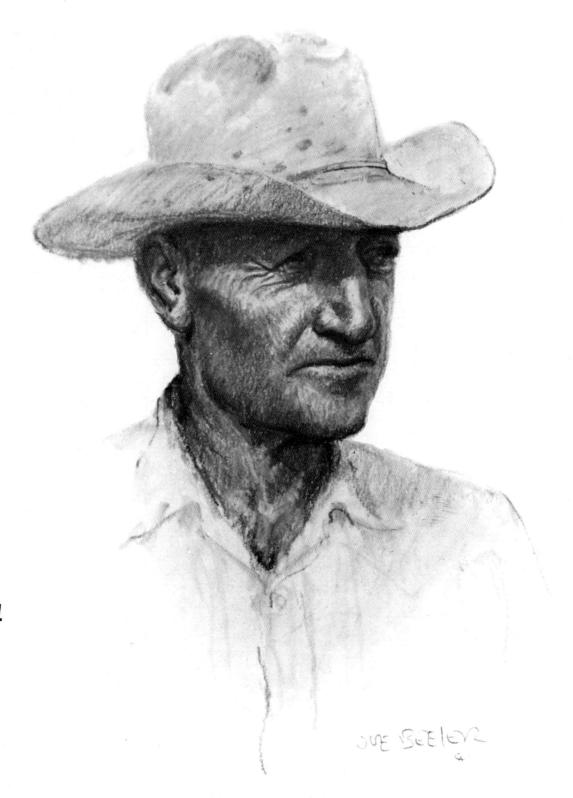

84

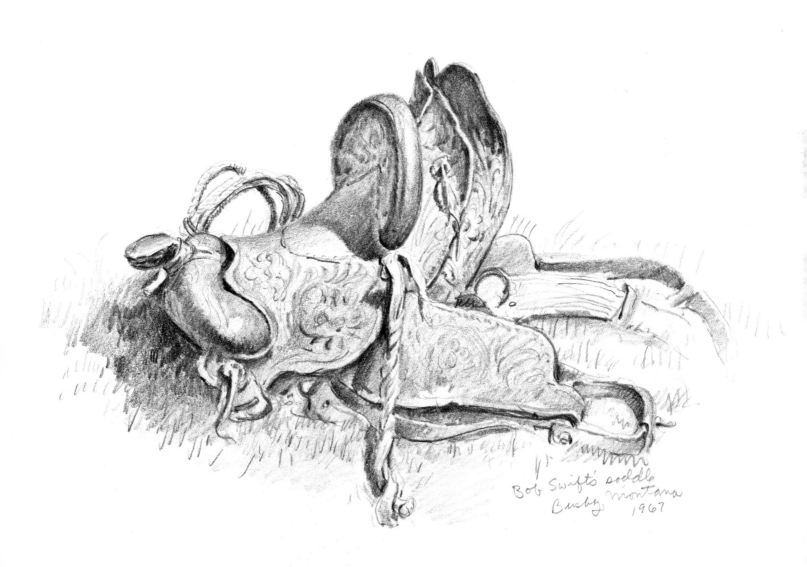

Bob Swift's saddle
Busby, Montana
1967

Sketches for Painting and Sculpture

I BELIEVE THAT DRAWING is the backbone of art. You cannot make a good painting out of a bad drawing. You can say the same for sculpture, only instead of a bad drawing underneath you have a poorly planned wire armature. Maybe one arm is too long; no amount of refining and care to the anatomy and surface will keep that arm from still being too long in the finished piece. Careful drawing and good planning in the beginning solve this type of thing. The artist must keep his drawing ability tuned by working at it constantly. Half of the drawings in this book were done while sitting with a pad in my lap and not necessarily at my studio drawing board surrounded by an array of pencils, erasers, lights and photographs. I draw because I like to draw, and this doesn't make it easy, it just makes it more pleasant for me.

86

Here is a sketch that started out to be a cowboy dressed for winter and ended up being a bronze sculpture, The Buffalo Hunter *(left).*

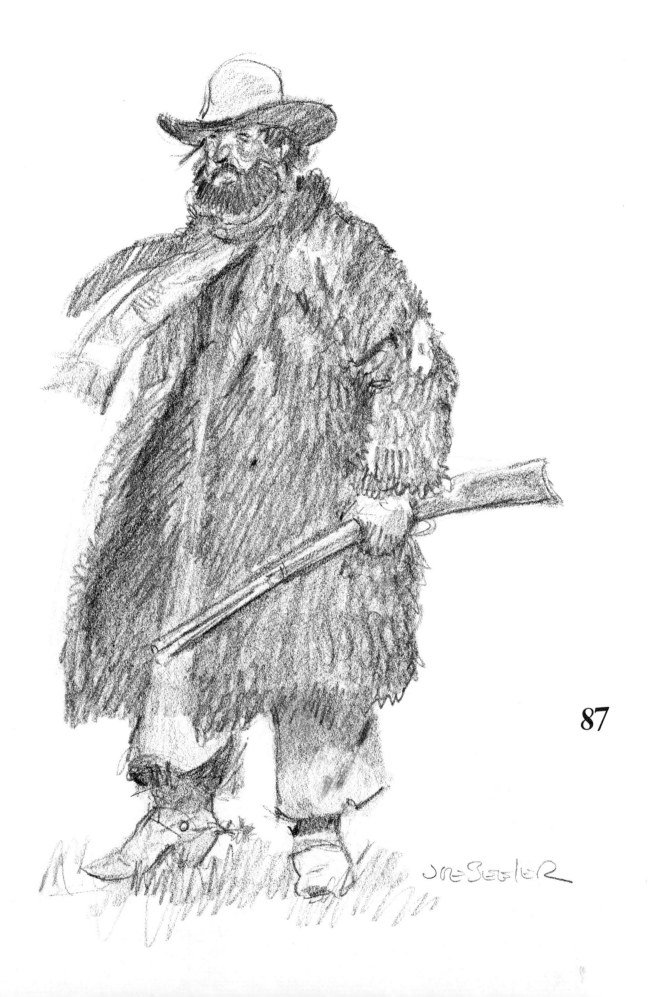

87

The first step in planning an oil painting or a piece of sculpture is getting your idea down on paper in the form of a drawing. In the case of a painting you start by doing a series of small sketches called thumbnail sketches. This allows you to place your subject matter and to establish the light and pattern in a small scale. Several of these are done and usually done quickly; not too much care is given at this time to refine the figures, etc. You then choose the one that seems to work best and proceed into your larger, working drawing, and sometimes even a color sketch is done. These little drawings are very important for here is where you catch the action or mood that will make or break the final painting.

88

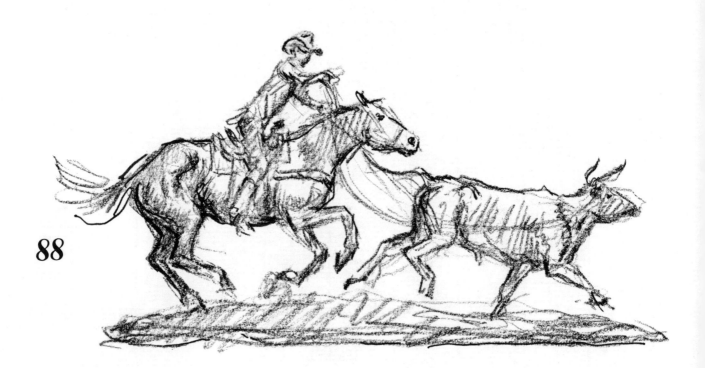

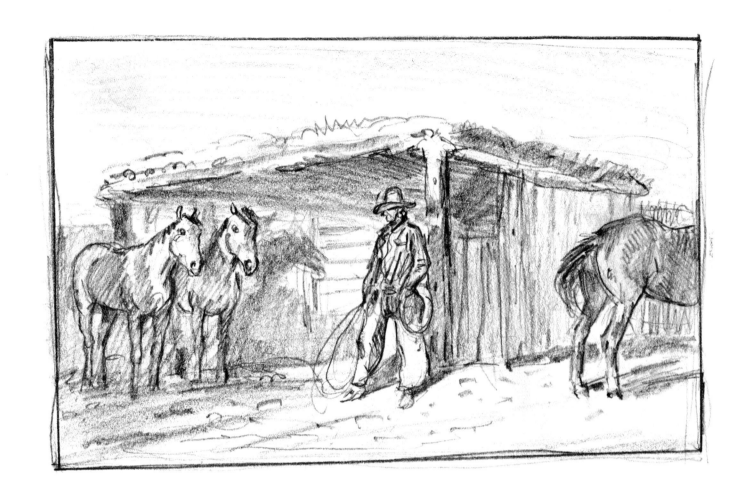

SEEKING DIRECTIONS

89

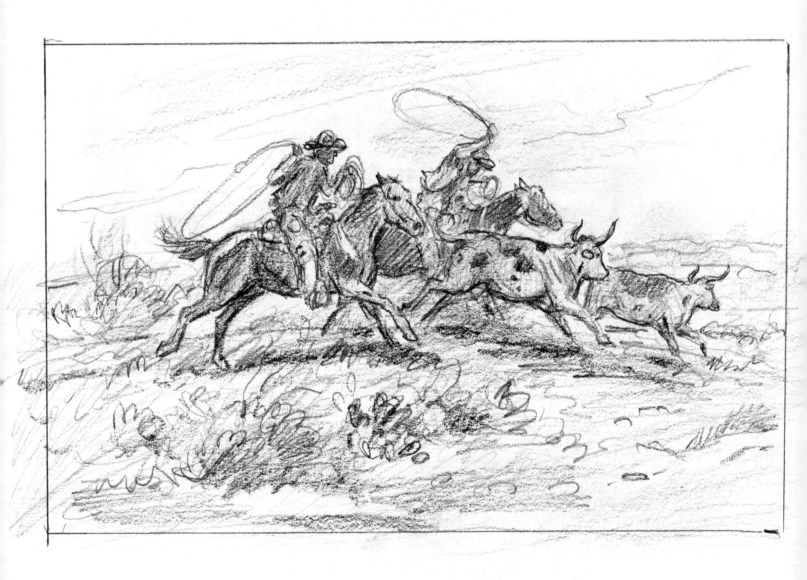

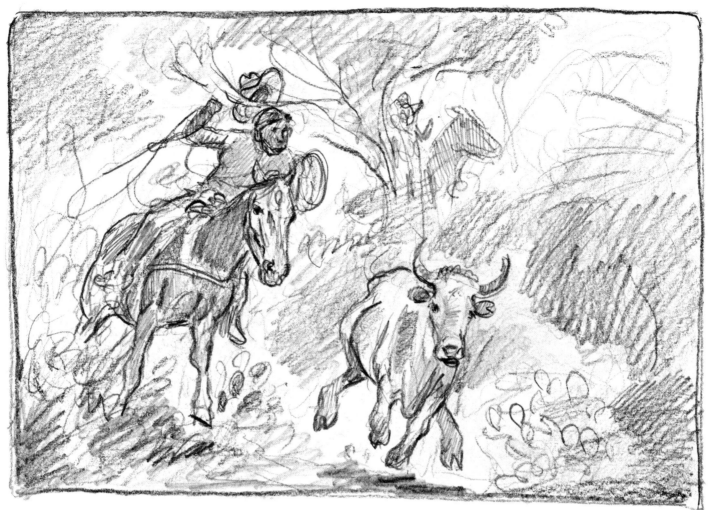

now or never

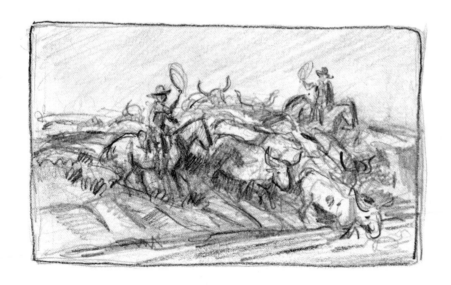

91

The large, working drawing is where you go to refining things, and great care is taken to make this the best you can. Corrections are made, and the drawing is completed to the last detail. Most of my efforts are from my imagination, and the drawing is completed without the aid of photos or models. But I do use my files now and then and look for things that will help me. In working this way, I am not beginning with the attitude that I am just going to render a photo. I would much rather produce a piece of art that was less than photographic perfection but one that had great feeling and heart. Rembrandt certainly summed it all up when he said, "Painting is not merely a question of technique. There must be temperament, character, and personality. Without these a canvas is dead."

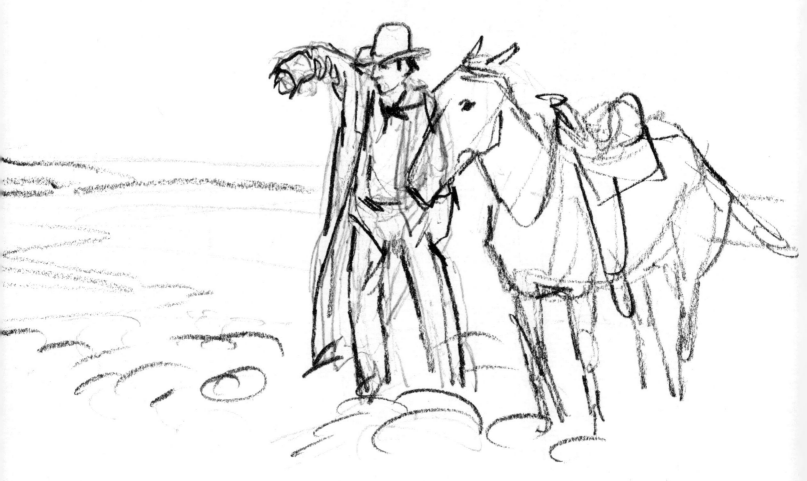

93

The sketches on the preceding pages and also on these two show the sequence in the development of an oil painting. This is not meant to be an exercise in putting on a raincoat, but to show my thinking in planning the painting, Spooked.

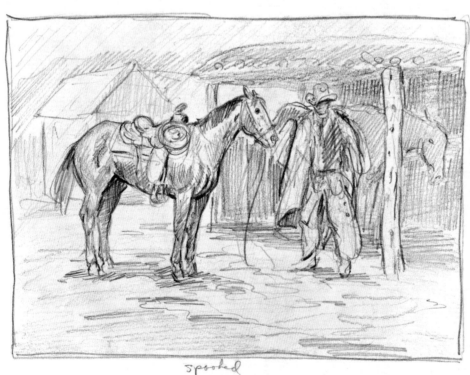

spooked

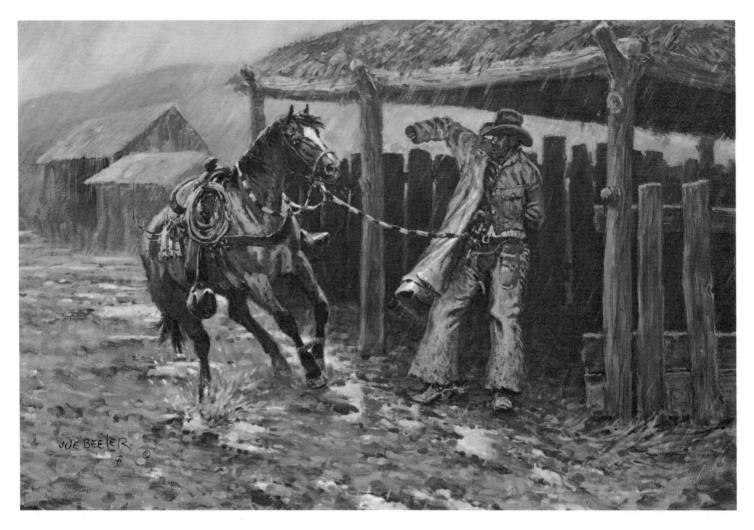

Spooked, from the collection of
Mr. and Mrs. Eddie Basha.

Most artists keep a pretty complete file system for research purposes. And along with photos, clippings, articles and pamphlets, his own field sketches are there for invaluable information. These are often small and quickly-done pencil sketches with written notes penciled in for color notes, etc. These are absolutely unimportant as far as their art value goes, but they are most important when the artist sits down to work on a major piece.

I have done a great deal of sketching while studying artifacts in museums. Sometimes the museum will have printed catalogs and other material with items illustrated, but so often they do not reproduce the little things that you always need. One of these little, hurried sketches at your fingertips at the right time, can make the difference sometimes in a large, important effort.

96

The importance of this was pointed out to me a long time ago by my friend Joe De Yong. Joe lived and painted and drew Indians and cowboys from Montana to California. He must have drawn constantly for I have seen boxes full of these small pencil sketches done all over the West. In later years after having moved to California from Montana where he had lived and studied with Charlie Russell, Joe became one of the leading people in the field of technical work for Hollywood. He worked on many of the really fine western movies as a technical advisor. He had his wealth of field studies to aid him in putting the proper costume on some western character. With the help of these early sketches and his good memory and general knowledge of the West, he was the top man in his field . . . besides being a fine artist. He encouraged me to do this same thing and always told me it would pay off someday . . . and it has and is.

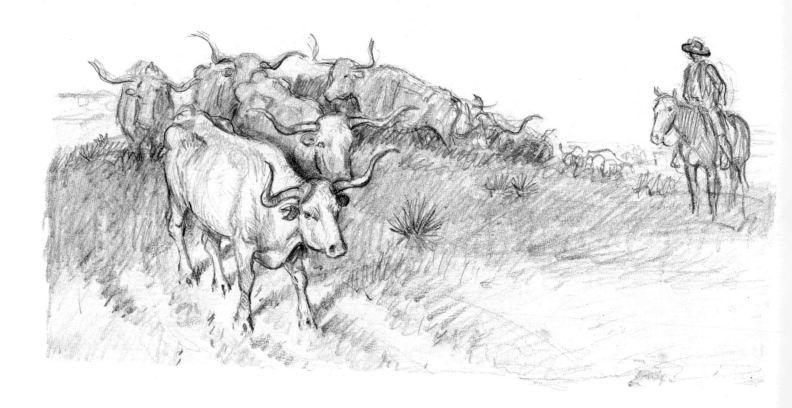

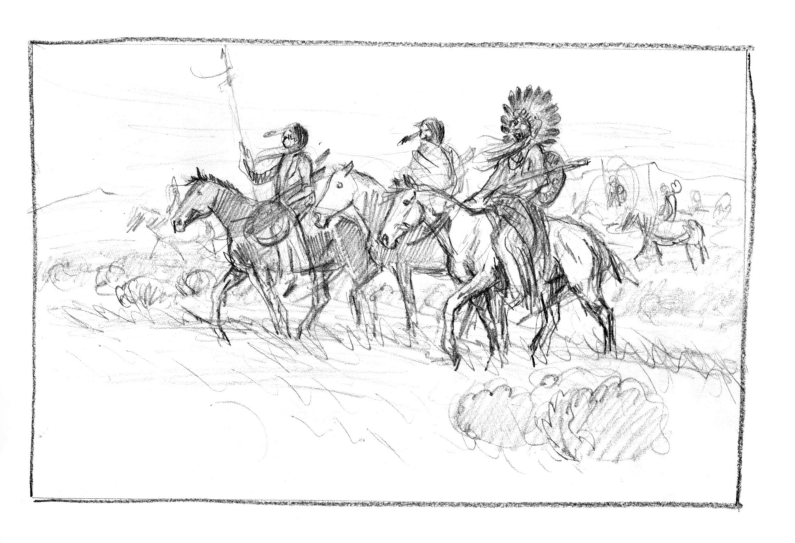

99

Horses

HORSES HAVE DIFFERENT PERSONALITIES, shapes and colors, just like people do, and they have different amounts of ability. I've put horses in about everything I've ever done . . . sometimes whether it called for a horse or not. I recall one time I was approached by an undertaker to do a mural in his casket room. We were broke as usual and I figured it didn't make any difference where the money was coming from, so I said, OK. He did try to work out a trade with me . . . which I didn't go for, but I did the mural . . . and it had a horse or two in it.

100

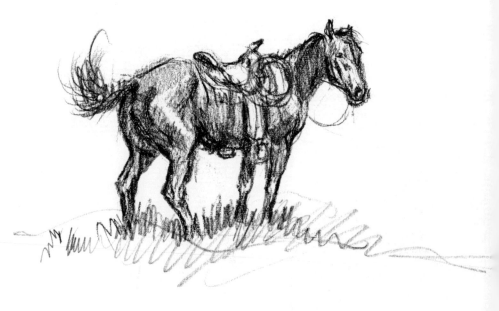

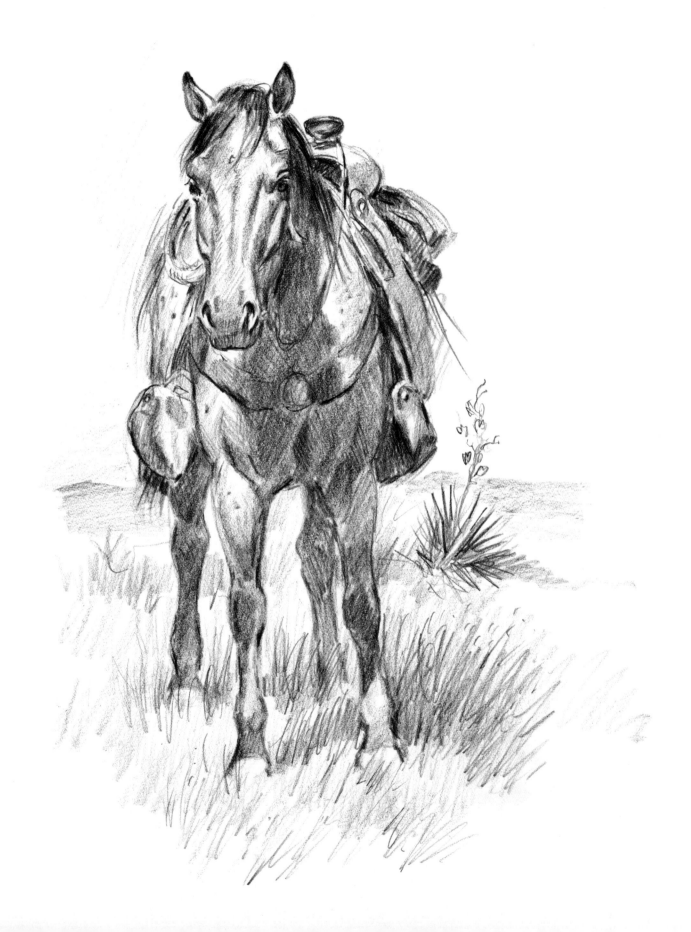

One of my first experiences of owning a horse goes way back. An old friend of mine, John Holmes, and I were out at the "killer" plant, hanging over the fence, looking over their horse herd. The Owens Brothers were famous for their horse and mule trading, and this particular set-up was one of the largest killing and processing plants for horses in the country. At that time there were supposed to be right at 10,000 head in their pens. We felt very bad that two boys like us

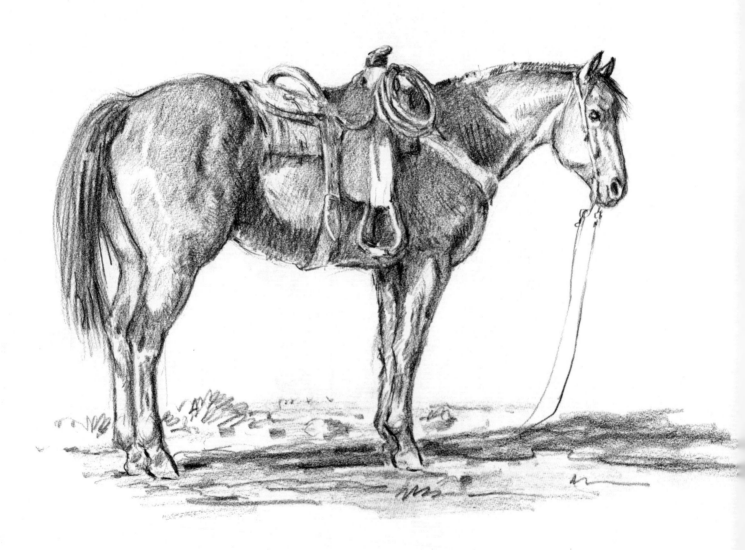

wanted and needed a horse as bad as we did, and here stood thousands of them waiting to be made into dog chow and glue. Many of these horses were too old to work or ride anymore and had been sold rather than put out to pasture by their owners. Some were sick and lame but others were plenty good looking and healthy with many miles left in them. We had heard they would sell you a horse, and you paid for them by the pound. John and I had saved up a little and were there to make a purchase. A nice, trim, little sorrel mare caught my eye, and John picked out a fine, big, red gelding that had been a cavalry horse and had a military brand on him. I paid $40.00 and he paid $60.00. We made the deal, and the only tack we had was the grass halter and lead rope that always went along with the deal. Both of us got bucked off twice trying to ride them out of the plant yard and ended up leading them out to the pasture from the back window of an old 1927 Packard. We each then invested another $20.00 in a saddle, and we were in business. There was an old-time horse trader by the name of Earl Green (no kin to Ben Green) that had a place right across the road from our pasture. We roped goats there and raised a lot of dust, and I was never long without a horse since.

Just putting a horse into a western picture is not all there is to being a western artist. There are many types of horses, and care and understanding must be given to the type of horse that goes into a given period. For instance, an 1880's cowboy would be riding a different type of horse than a cowboy portrayed in modern times. And you would not put a Sioux warrior on a quarter horse or a Morgan. The wiry little Spanish-type horse was used throughout the Southwest by both the cowboy and the Indian and the mule was used widely for riding and other purposes. A horse that is worked and used hard has more

103

definition in his muscle structure . . . just like a man has. You wouldn't want to put a mountain man of the 1850's on a fat, little, butterball-type horse and you wouldn't want to put a cowboy roping a steer off of a Tennessee walking horse.

I always try to put my cowboys on good horses because a cowboy always rode a good horse whenever he could . . . now or in 1880. I sketch or take photos of different types of horses when I find them for use in my work later. I have four good types of horses standing in my own corral which I draw from and use whenever I run into anatomy problems.

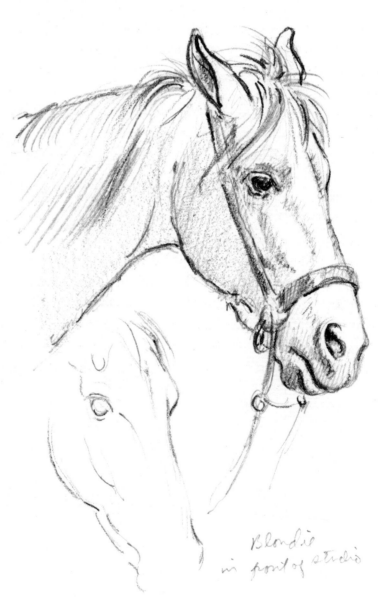

104

Blondie
in front of studio

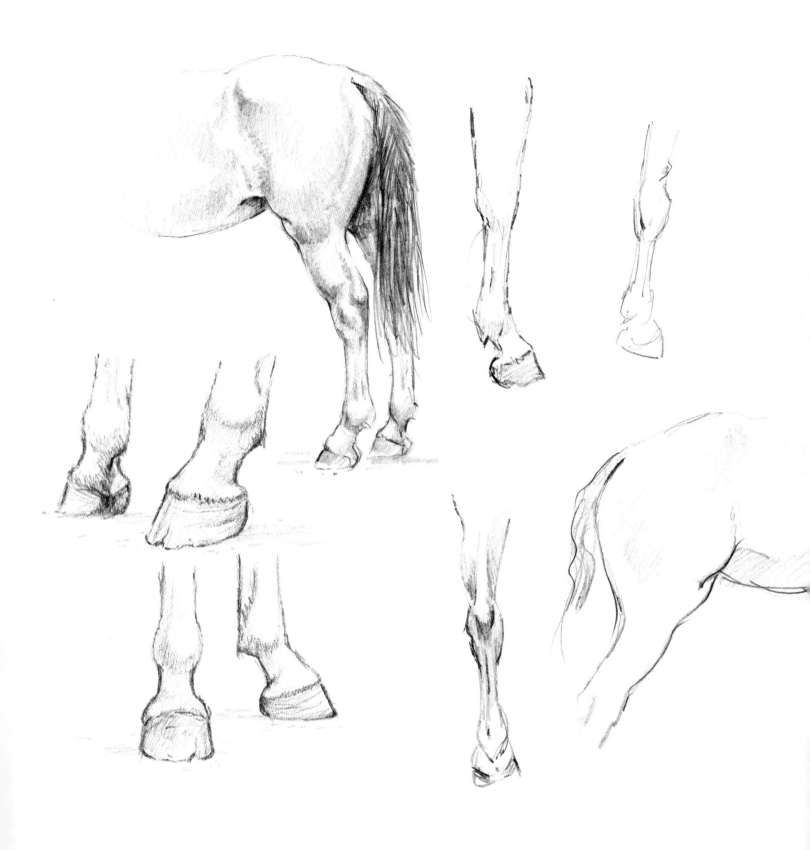

The quarter horse is probably the most widely-used horse in the West today. He is an athlete. There are a lot of different types of quarter horses too, and in the last 15 or 20 years the breeders have gotten away from the bulldog-type horse that used to be so common. Now, these horses have a lot more Thoroughbred in them, which gives them a trimmer look and gives them the speed to catch the fast cattle. But many of the best horses would never win a halter class, and this is where we get back into that character I like so much.

Today there are still good examples of the different kinds of horses that were used throughout the West. I like to seek out these types and draw them and record them so that later when I am painting or working on the model for a bronze, I have that information at hand.

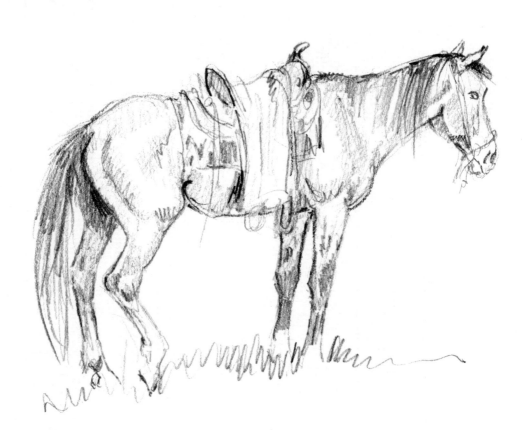

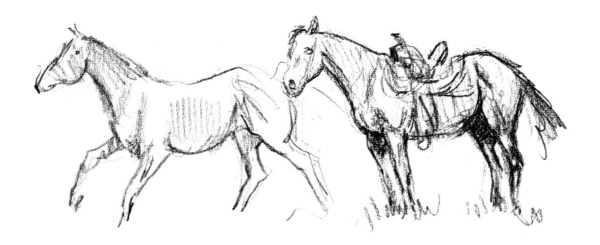

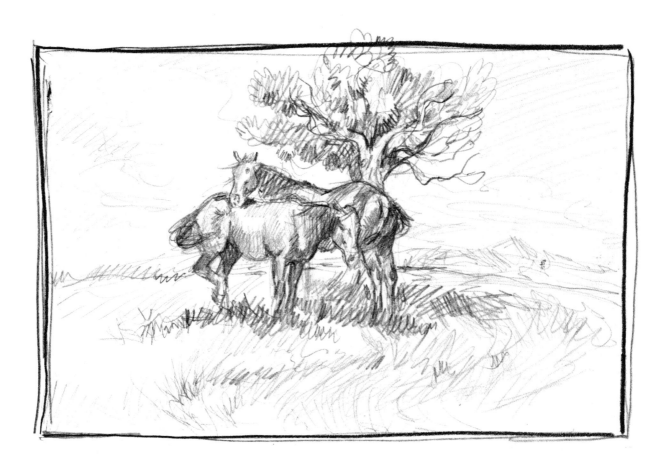

The Navajos

NOWHERE IN THIS COUNTRY will you find a people more colorful and interesting than the Navajo Indians. Artists have been using them for subject matter since the white man first came in contact with them. They cling to their culture and heritage, and while we can see changes taking place today, the majority of them hold doggedly to their old ways.

Seeing and studying them is not difficult; you can go into any northern Arizona town on Saturday and sit in your car or walk the streets and half the citizens you see will be Navajos in off the reservation doing their visiting and shopping. Navajos still love their horses, and I have enjoyed attending their rodeos and ropin's, and this is where you see a lot of the old-timers . . . they will come out for that when they will come out for nothing else. They are natural horsemen, and when properly mounted and with practice, make good ropers.

108

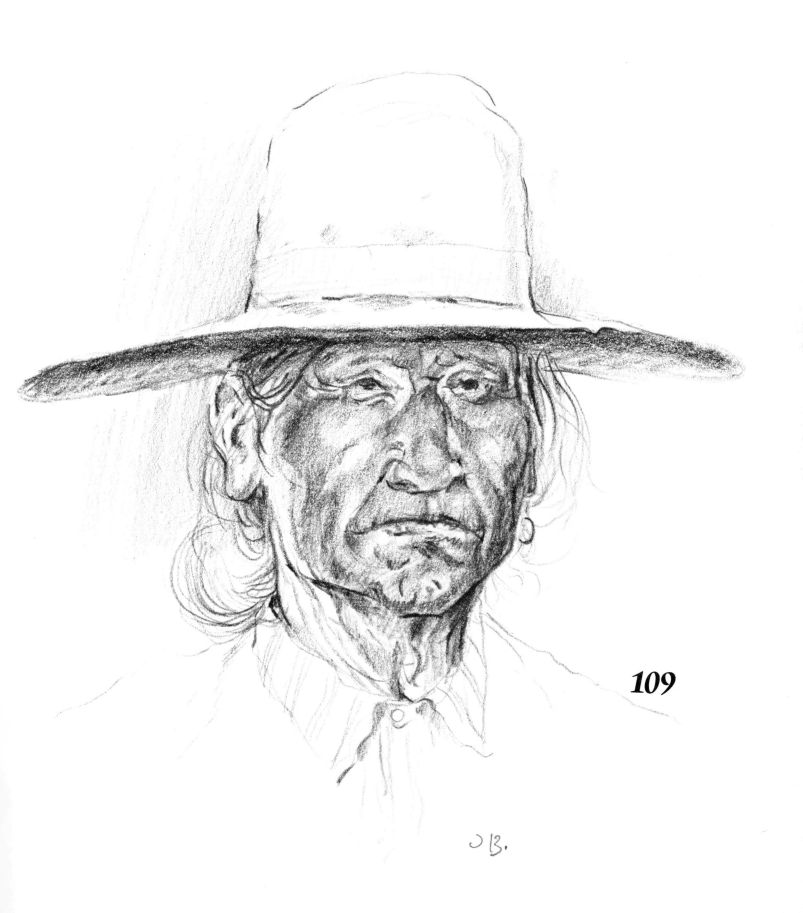

109

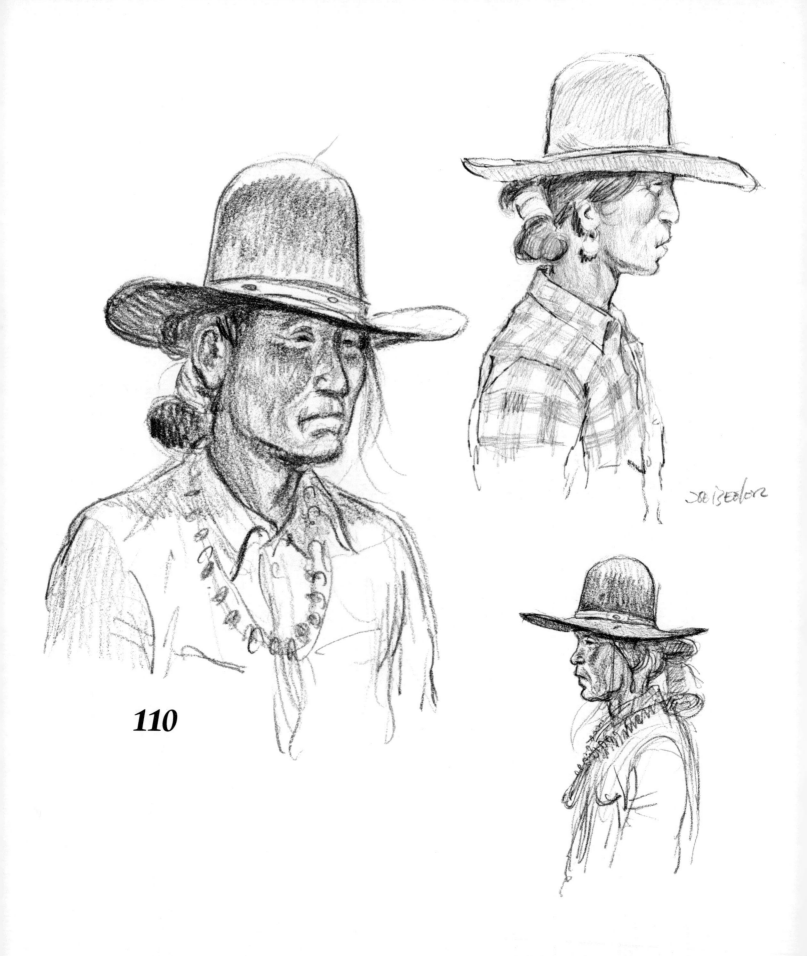

110

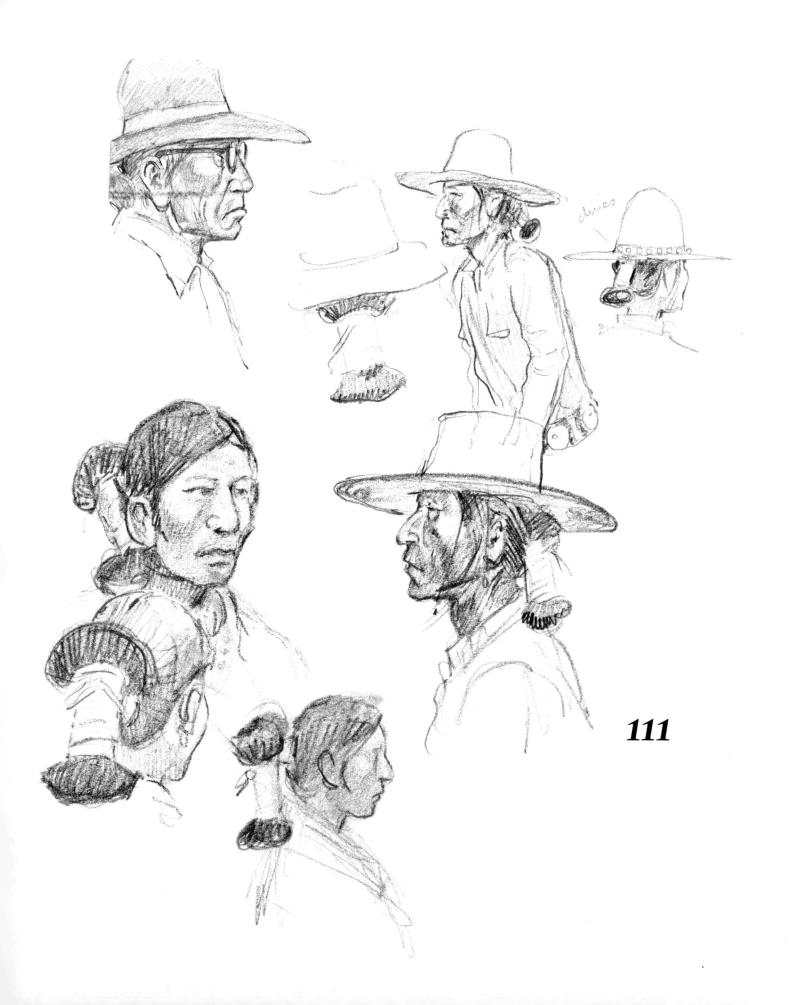

111

Sometimes several of us from Sedona will load our horses and go to one of the jackpot ropings on the reservation. Along with the fun of roping, I enjoy the opportunity to study them at close hand. My procedure in sketching them is to watch them and study them carefully then go to my truck and make a quick drawing of my impression. Another way that works for me is to park near and draw them from my truck without them knowing it. If they become aware of what I'm doing, they become self-conscious or embarrassed . . . as most anyone does, and they'll move. So most of my sketches are from memory.

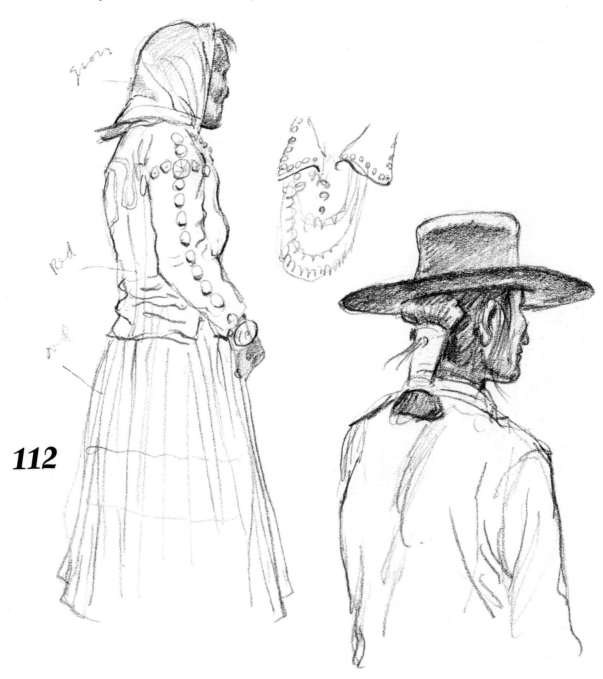

112

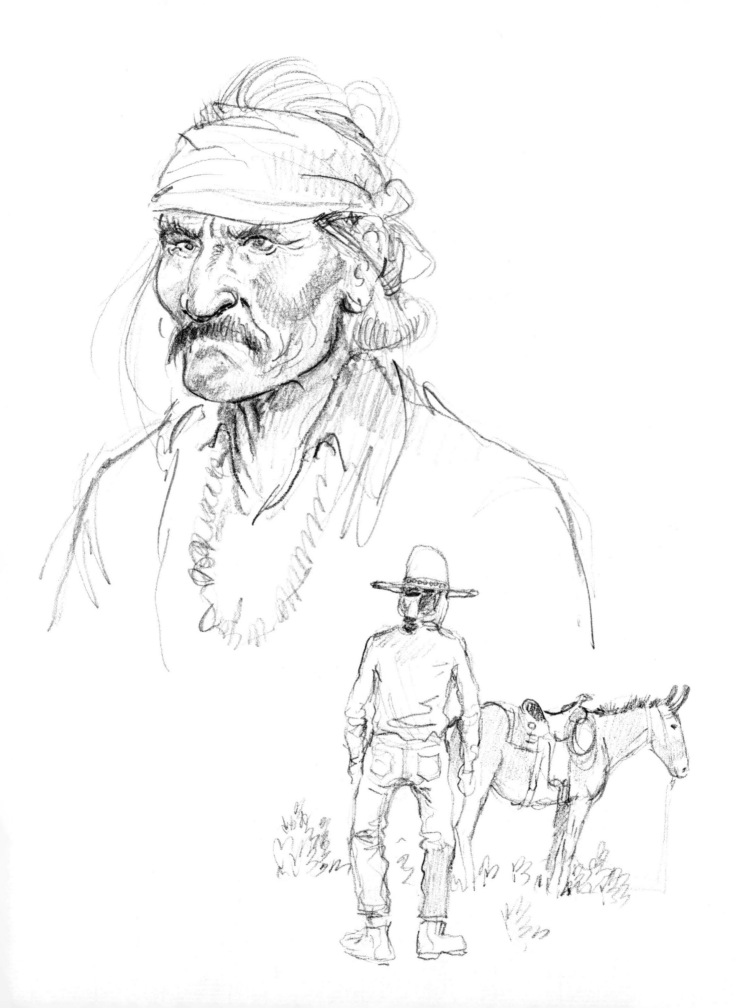

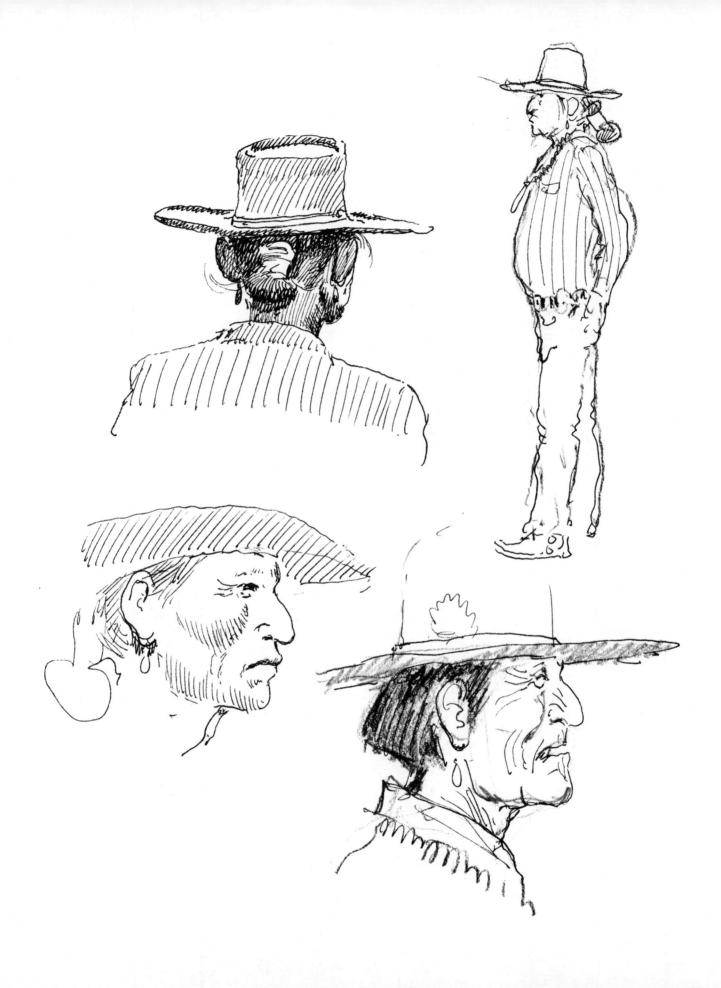

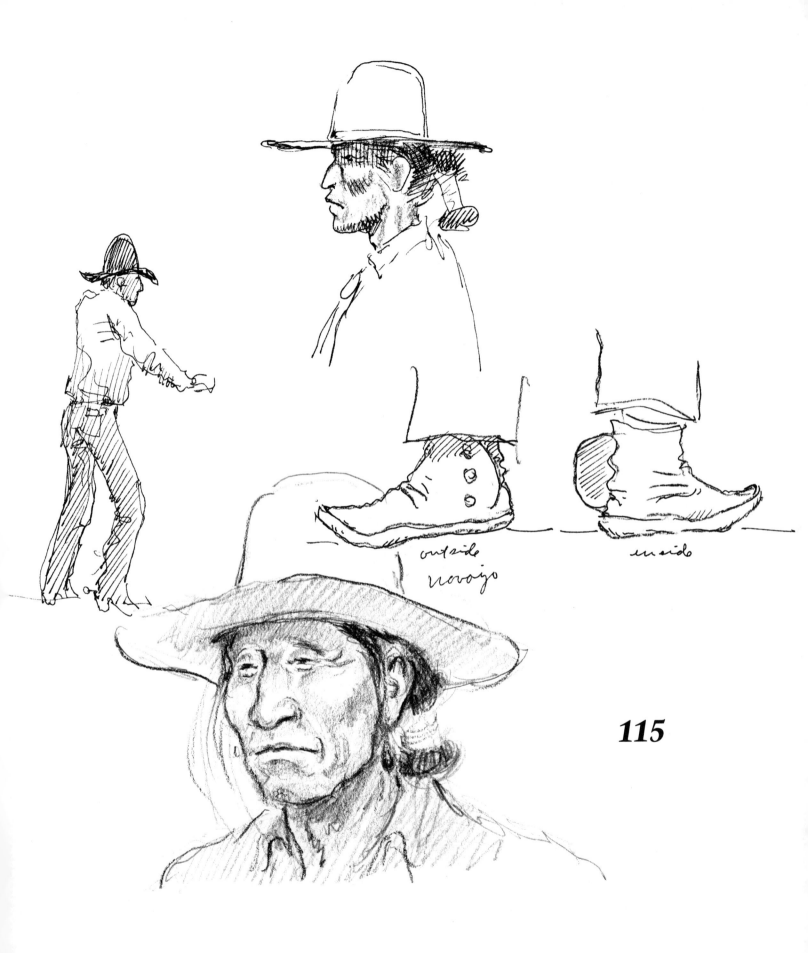

outside
navajo

inside

115

I recall driving alone over to Gallup to attend the Ceremonials they have there each summer. My Studebaker pickup had a canvas cover over the back. During the day it began to rain, and it didn't let up. I was parked in an ideal spot to observe everyone so I sat in the back of my truck, drawing the Navajos as they went on about their business of having a good time at the powwow. Two young Navajo men hitched a ride back toward Flagstaff with me. On the way they began to hum and sing Indian songs. I surprised them by starting to sing along with them, and we ended up singing Indian songs all the way home.

Periodically we make trips up to the reservation to gather material for subjects. The many trading posts serve as good contacts and places to sketch as the Navajos gather there to do their shopping and to visit. They will still be a colorful people long after the rest of us have become sterilized and homogenized.

116

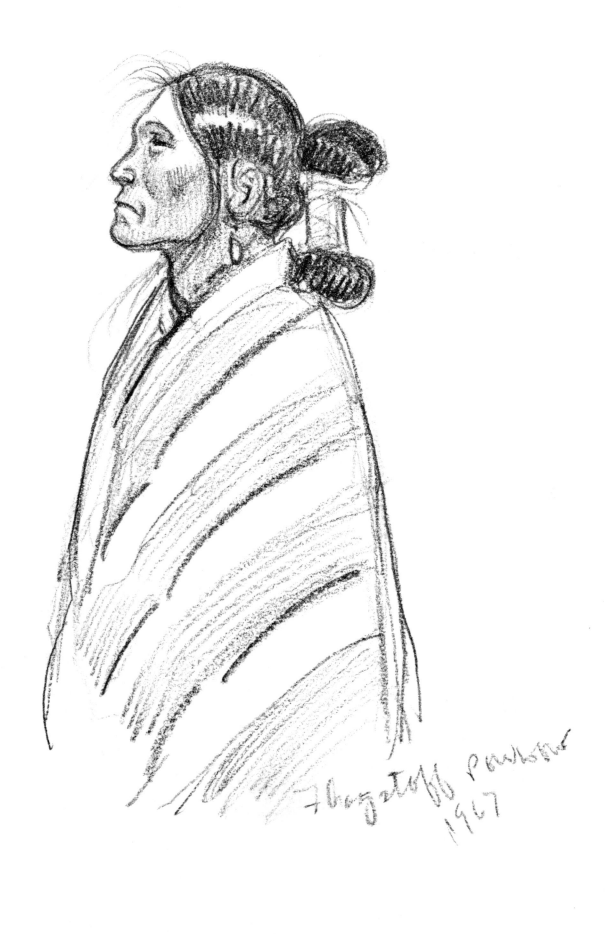

Book Illustrations

IT IS A GREAT JOY for me to see a piece of work reproduced after
working and planning such a drawing as an illustration for a book. In
the case of color, however, it is sometimes more of a shock than joy that
you feel. But book illustrating is what I have had the most experience
with, and these are usually pen and ink or pencil drawings in black and
white. I get a feeling of accomplishment to see something I've done
combined with a well-written text and good design, to end up with a
finished product that in total is a fine graphic production.

Illustration from *The Last Trail
Drive Through Downtown Dallas*,
Northland Press, 1971.

118

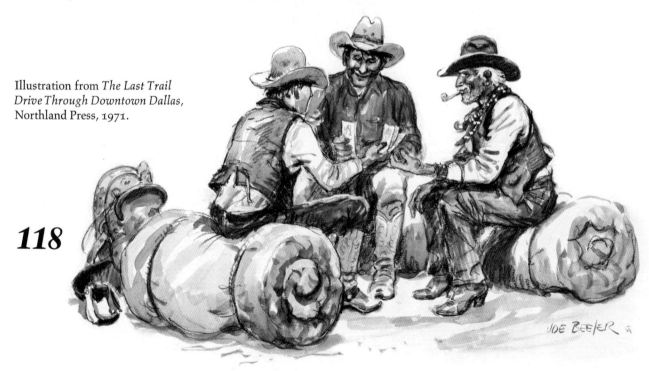

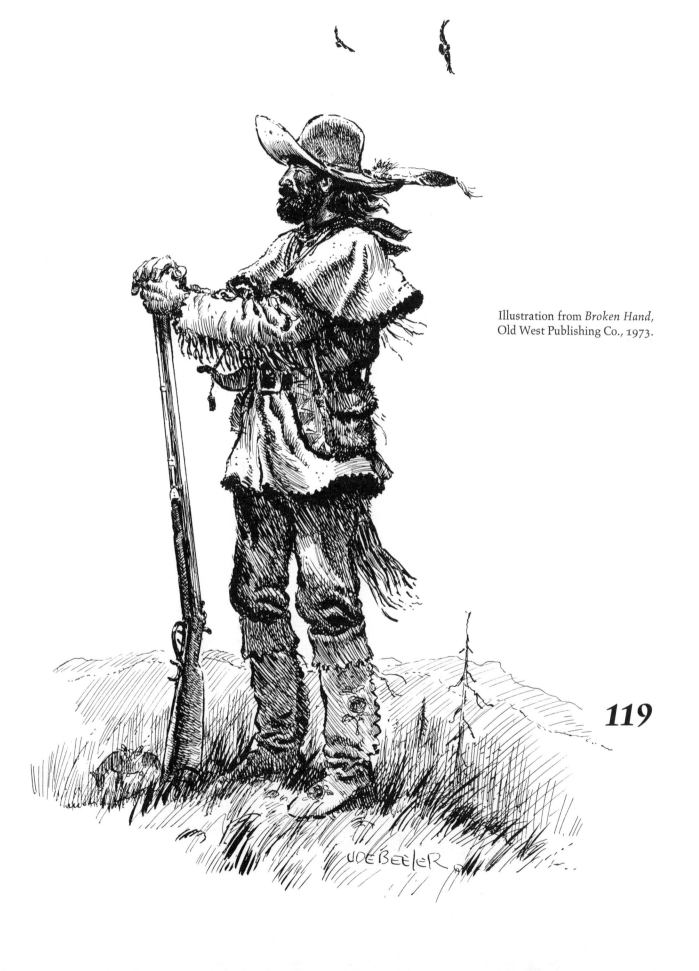

Illustration from *Broken Hand*,
Old West Publishing Co., 1973.

119

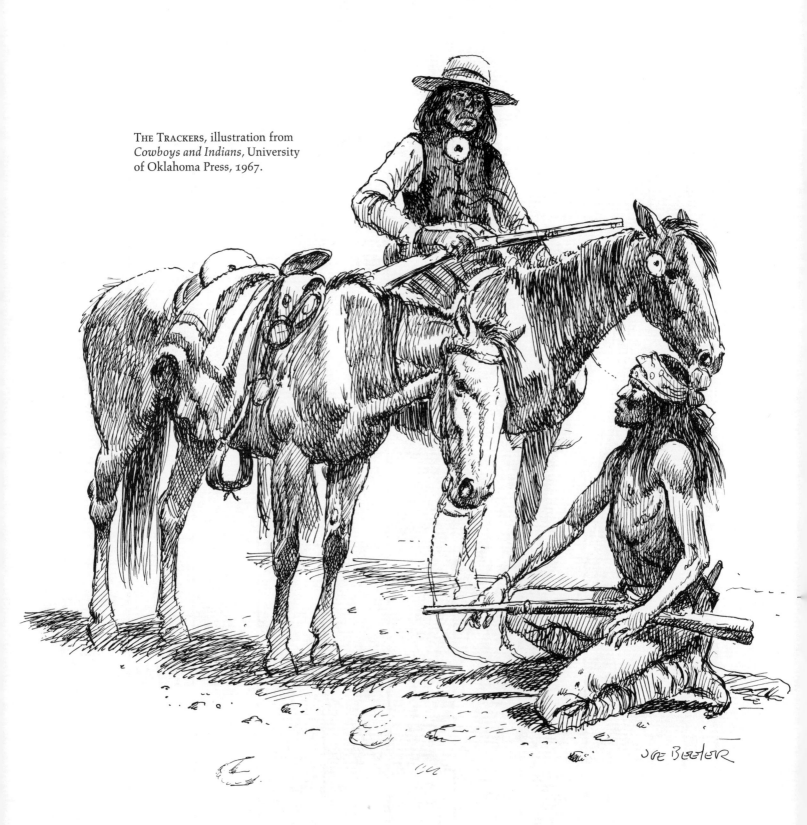

THE TRACKERS, illustration from *Cowboys and Indians*, University of Oklahoma Press, 1967.

My first entry into this field was back in Oklahoma. I had a family and was just starting out. Ignorance is bliss they say, and we were full of bliss. One of my first big breaks came when Savoie Lottinville, then the head of the University of Oklahoma Press, saw my work and gave me my first chance to illustrate a book. This came at a very important time for me; it gave us a boost that we needed badly. I did a great many jobs for them after that, and in 1967 my own book, *Cowboys and Indians,* was published by the University of Oklahoma Press. It was one of the first done that related to a current western artist. The subjects I illustrated related to the West right from the beginning and have ever since. This is not to say that I wouldn't try my hand at illustrating another kind of story if I thought I could do it justice . . . like a pirate cowboy or a Mongolian horseman story . . . something different.

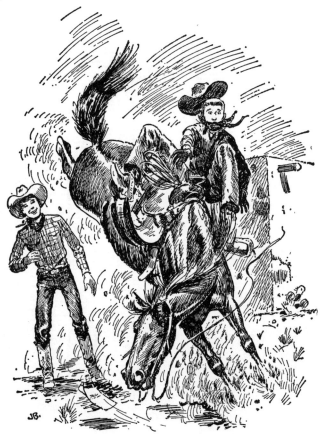

Illustration from *The Phantom of Wolf Creek,* Grosset and Dunlap, 1963.

121

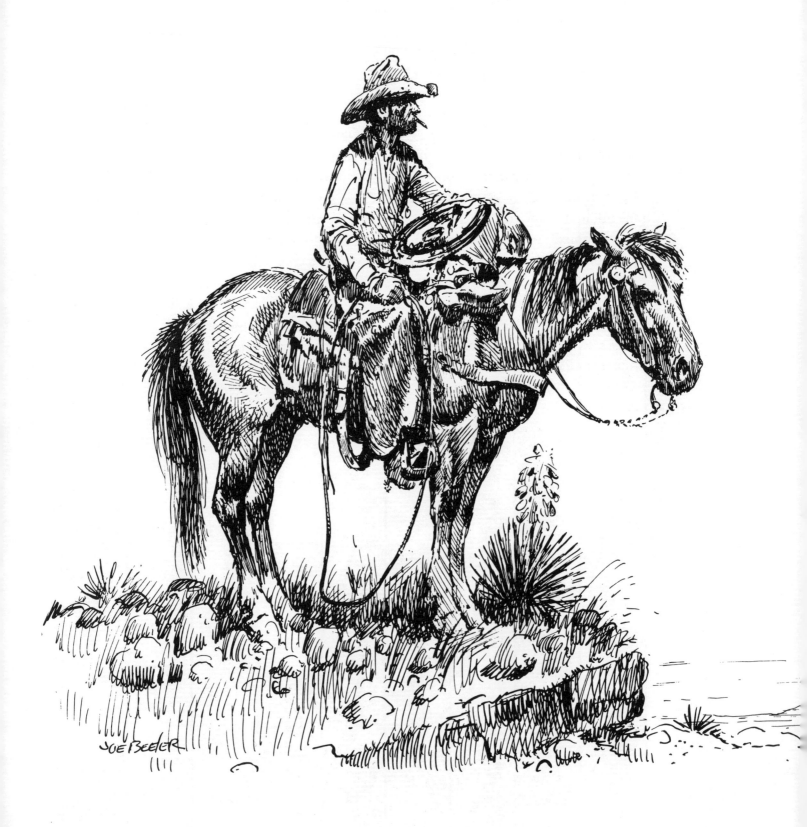

The challenge for me in book illustrating has been trying to feel and see things as the author does. You must design your work to a given size and shape that it is to be reproduced (I just had to redo a whole set of illustrations from not reading the proportions over carefully . . . the publisher said my drawing was fine, but my math was terrible) and handle the drawing in a style and manner that will not give problems when it is reproduced. That is to say, keep the pen and inks open enough so that the lines are distinct and don't blotch up when reduced and don't use tones in wash drawings that are impossible or difficult to reproduce. In handling the work, you must keep in mind what the final results are intended for.

THE BRUSH POPPER, illustration from *Cowboys and Indians*, University of Oklahoma Press, 1967.

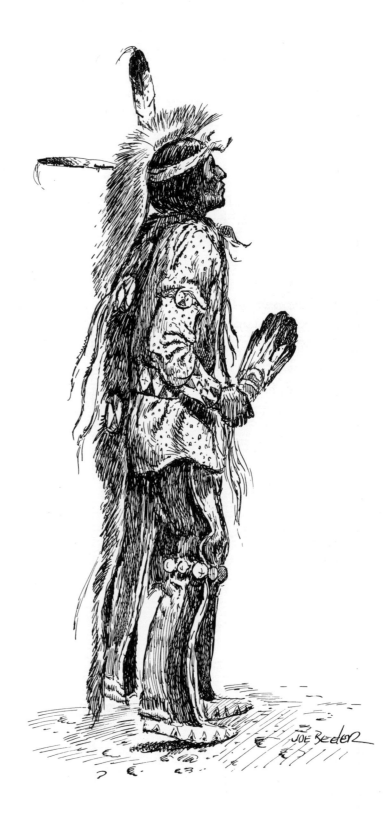

Osage Straight Dancer, illustration from *Cowboys and Indians*, University of Oklahoma Press, 1967.

124

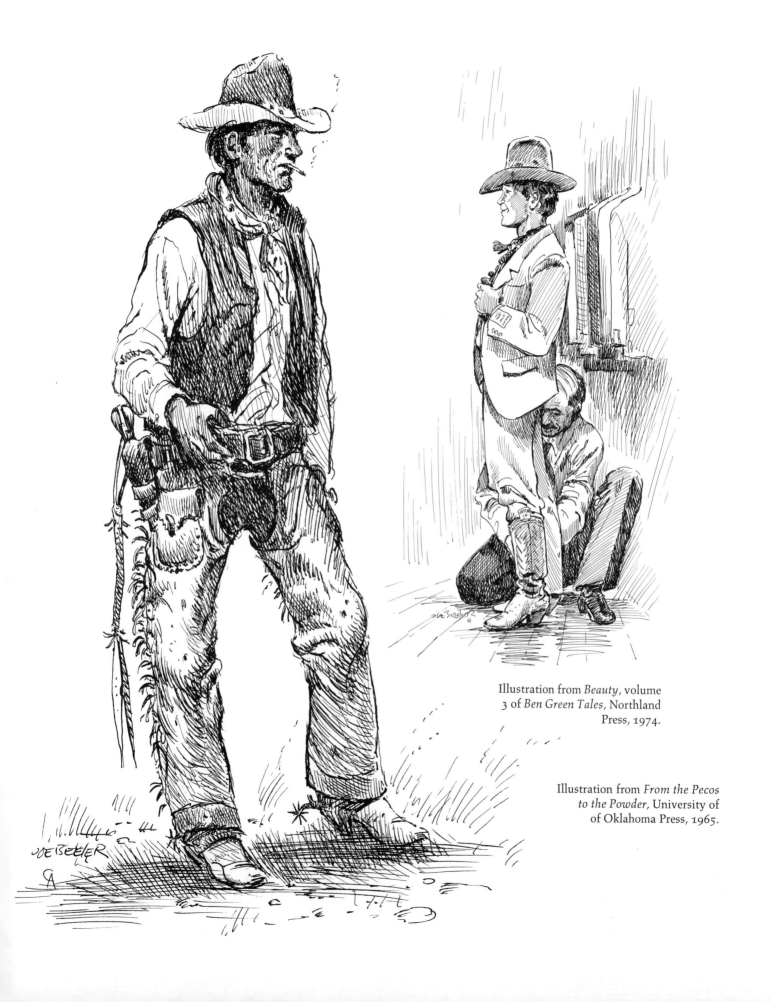

Illustration from *Beauty*, volume
3 of *Ben Green Tales*, Northland
Press, 1974.

Illustration from *From the Pecos
to the Powder*, University of
of Oklahoma Press, 1965.

Illustration from *Some More Horse Tradin'*, Alfred A. Knopf, 1972.

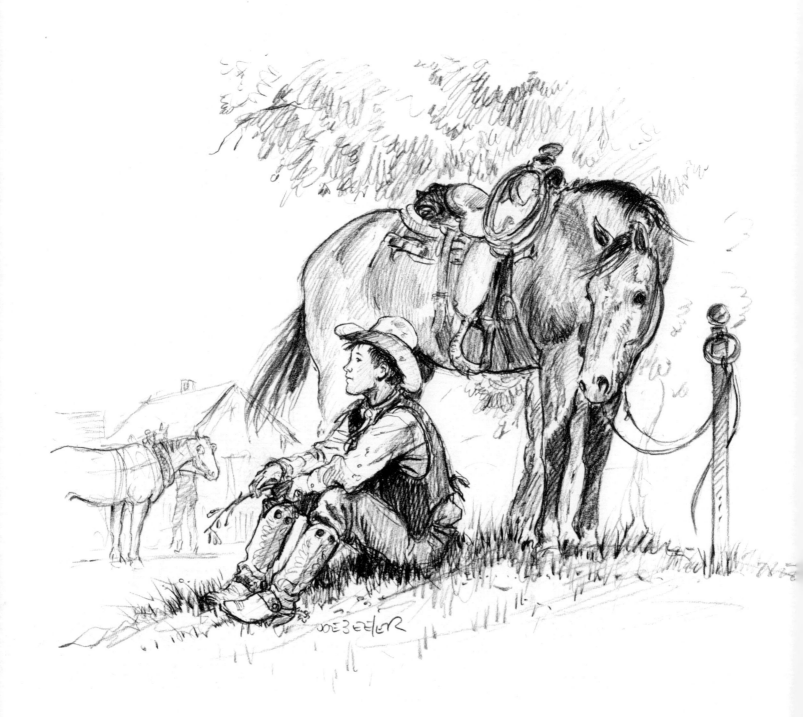

Catching the character and flavor of the story is very important to me. I have enjoyed working on Ben Green's books from this point of view. Ben gets so much character and grass roots philosophy into his stories that it is a challenge and a pleasure for me to try and do the same. I feel my drawings must try and match his words.

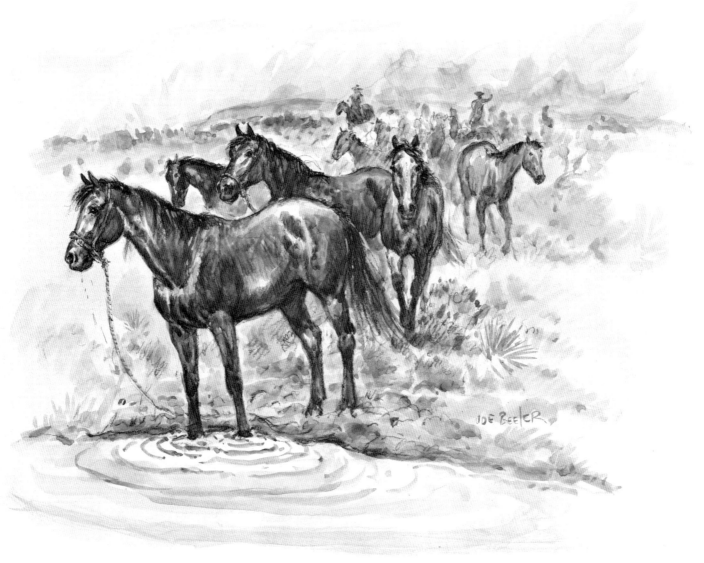

Illustration from *A Thousand Miles of Mustangin'*, Northland Press, 1972.

Whether I am doing an illustration or a painting, I stay away from anything mechanical, both in my choice of subject matter and my working procedure. I don't get along with mechanical things and don't have any sympathy for them or interest in them. I basically sit down and do thumbnail sketches of those ideas in the story that seem to be the most interesting and pick points along in the story that will space the illustrations pleasantly throughout the book. I then proceed right into the finished product without any delays, fanfare or overlays. Mechanical gadgets just sidetrack me.

Illustration from *The Peralta Grant*, University of Oklahoma Press, 1960.

128

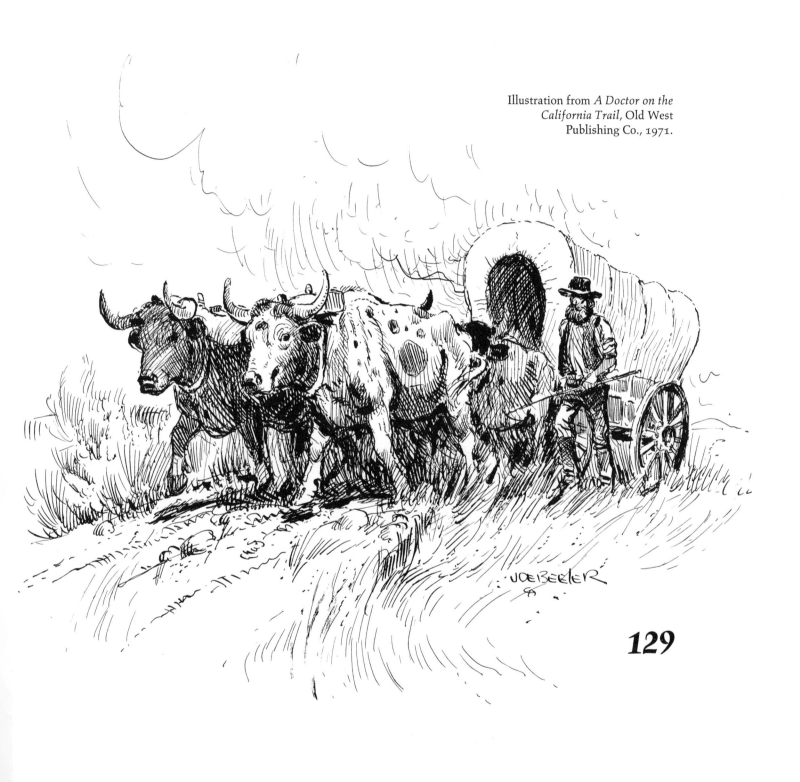

Illustration from *A Doctor on the California Trail*, Old West Publishing Co., 1971.

129

*These two illustrations reflect the
mood and action that takes place in
Elijah, a lively novel about the
struggles of a mountain man.*

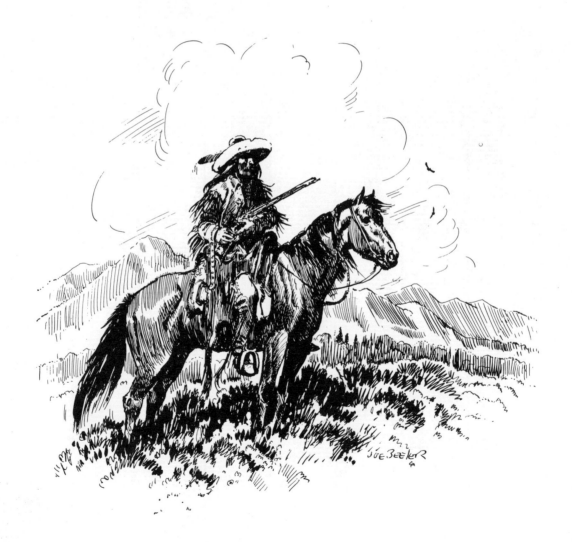

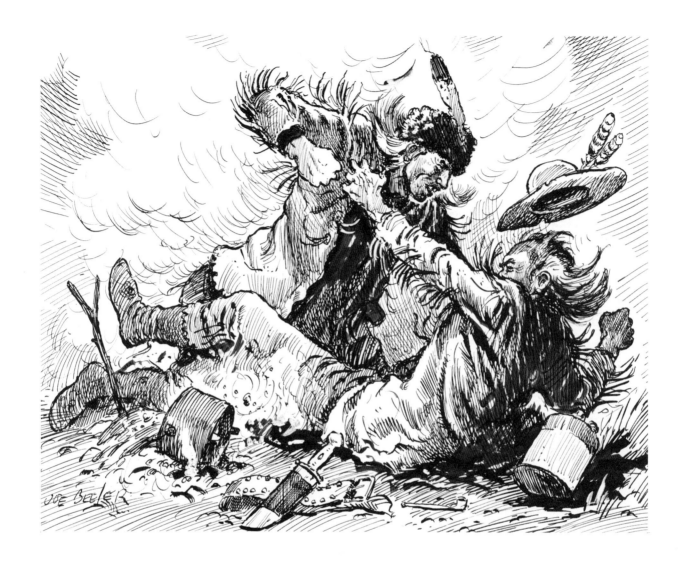

The illustrations on these two
pages are from *Elijah*, Northland
Press, 1973.

Lithographs

MY FIRST AWARENESS of lithography came while attending Tulsa University. I took a class in this from Alexander Hogue. Each student did several works and carried the whole printing process through from start to finish. The only ones I have left of those early works are these two illustrated here: "The Tail Dance" and "A Night in Harlem." The subject matter for "A Night in Harlem" was done from memory after several of us took in a big carnival in Muskogee, Oklahoma. "A Night in Harlem" was one of the shows, and it had the flavor of the old-time vaudeville acts.

132

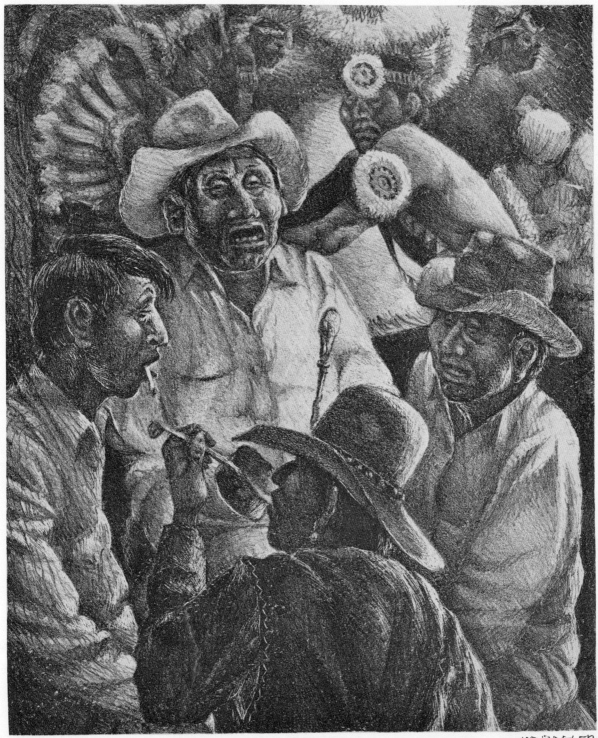

TAIL DANCE JOE BEELER

I never had the opportunity again to do a lithograph after I left school for there is a great deal of equipment and knowledge needed to produce one. So I forgot about it. Just a few years ago I became aware of the interest in lithography again. Several of my contemporaries had done lithographs including Tom Ryan and Gordon Snidow. As it looked like fun to me, I thought I would try one again. Gordon was working with the Tamarind Institute at the University of New Mexico and through him I got an appointment and went over and worked on several at one time.

The process was discovered and developed into a fine art in France. The two basic differences between a lithograph and an ordinary drawing on paper are, instead of making your drawing on paper, you're doing it on a large, fine, flat stone and you do your drawing in reverse. It's the latter that seemed to me would cause me the most trouble, but once you get used to it, you can work that way. The process is this — your drawing is made on a stone that is ground so fine the texture is just like the finest paper. You use a special lithopencil that is similar to a grease pencil, and they come in different hardnesses. These stones vary in size. The ones I used at Tamarind to do these lithographs were so heavy they are brought to your table by a mechanical forklift and set down and never moved again until you're finished.

134

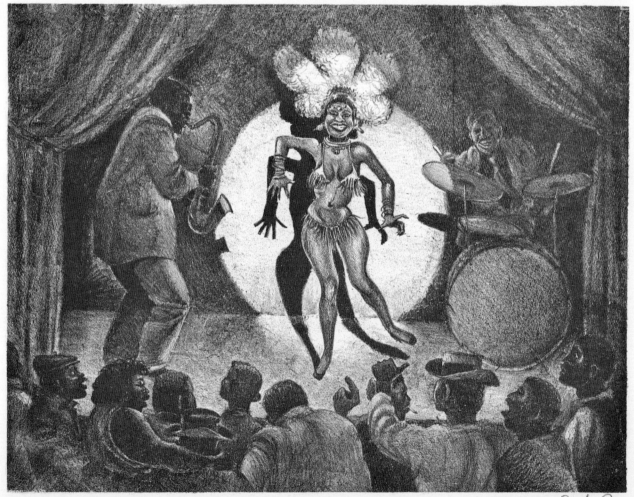

a Night in Harlem JOE BEELER

I enjoy working in this medium for it is drawing, just in a different form. And for the artist who is very busy and is lucky enough to have great demand for his work, this process allows him to offer a piece of his work that he can be proud of, to many more people. This also is appealing to young collectors who cannot afford more expensive works but who would like something representative of certain artist's work.

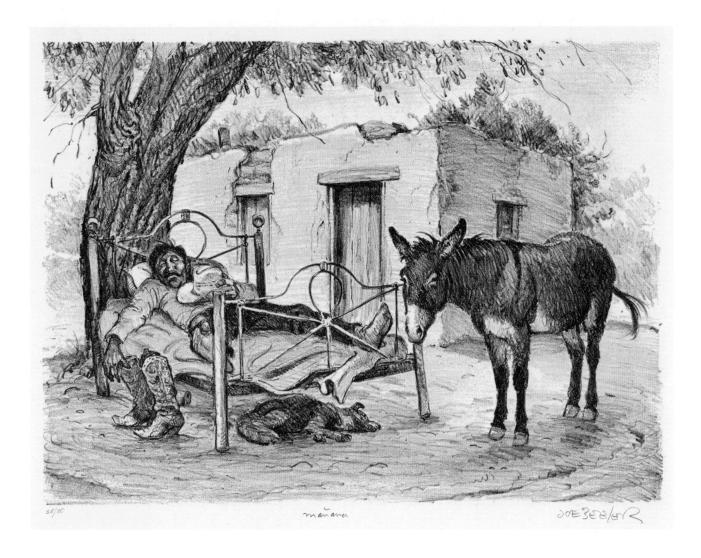

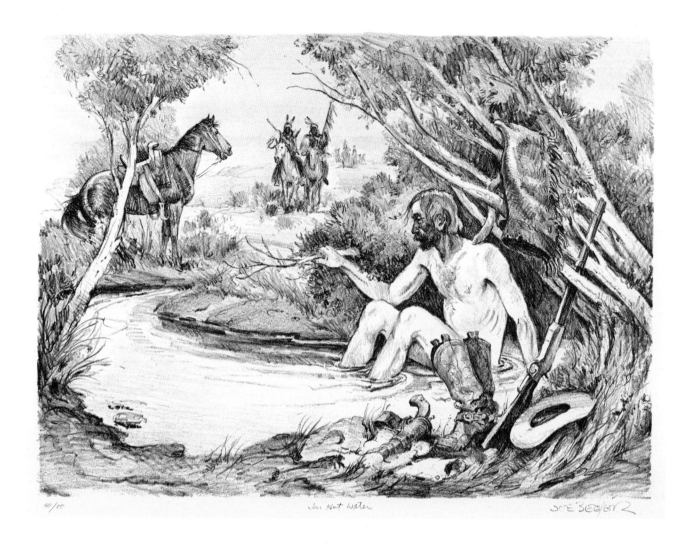

41/80 In Hot Water Jim Seefer

137

When you have completed your drawing, and you think it is ready to print, it goes through an etching process. This is to sensitize the stone to accept the ink, and this way it will work like a printing plate. All the printing is done by hand. The stone is inked with a handroller after it has been placed on the press. The paper and pads are placed carefully over the stone; then a crank is turned and the table is passed under a large roller which applies pressure against the stone and paper as it moves. The pads are lifted up from the stone, the paper carefully pulled up and you have a fine black and white reproduction. Color can also be used, but I have not tried this. The quantity of prints pulled depends on the artist. Some do as few as 10 or 20, others do as many as 250 or 300 . . . or more. After completion each print is signed, numbered and documented. The printer oftentimes adds his signature by placing his chop, which is like a brand, on the print.

Today there is a great interest in prints of all kinds, but lithography, along with etching dry point, wood-block prints and only a few other processes, are the only ones really considered fine art processes. Mass mechanical processes are used sometimes to make a print, and then it is signed by the artist . . . and especially if it is black and white and signed, the collector is sometimes led to believe this is a stone lithograph and more valuable than it really is.

138

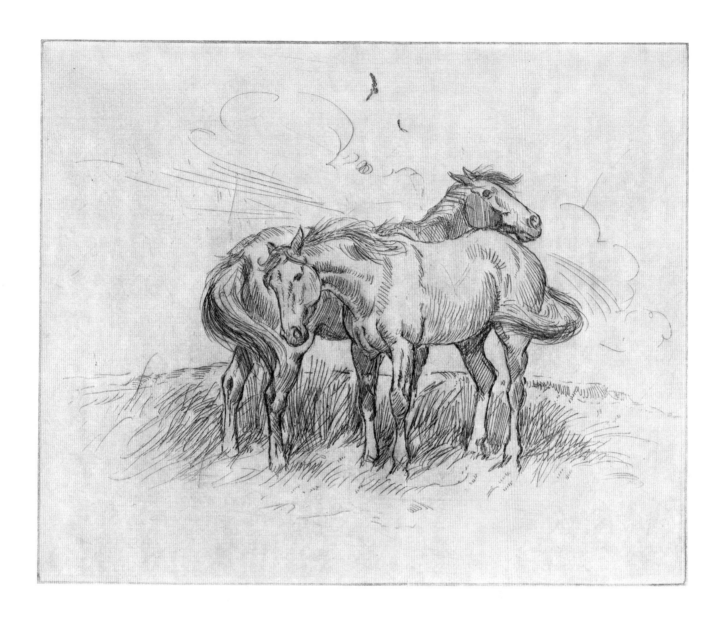

Tom Sander said to me, one day
while visiting him in his Montana
studio, if I would sit down and do
an etching, he would print it. This is
it, my one and only effort in this
medium.

139

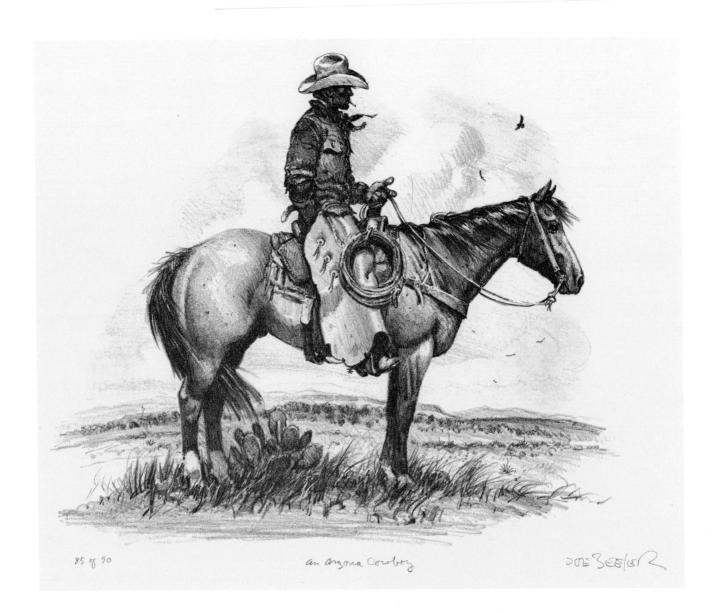

85 of 90 an arizona Cowboy JOE BEELER

140